ESSENTIALS

DIGITAL
PHOTOGRAPHY

ESSENTIALS

DIGITAL
PHOTOGRAPHY

igloo

Published by Igloo Books Limited
Henson Way
Telford Way Industrial Estate
Kettering
Northants
NN16 8PX
info@igloo-books.com

This edition published 2005

ISBN 1-84561-025-3

Project management: Kandour Ltd

Editorial and design management: Emma Hayley and Jenny Ross
Author: Duane Harewood
Text design and layout: Diana Friedrich
Cover design: Chris Readlamb
Cover image: With thanks to Sony
Photography and Illustrations: A J Basgallop, A J Holtom, Photos.com, Sony, Nikon, Hassleblad,
Metz, Linhof, Praktica, Epson, Eastman Kodak Company, Fujifilm, Pentax, Konica Minolta,
Mamiya, SanDisk Corporation, Adobe Photoshop, Velbon, Slik, Intro 2020, Microsoft Corporation,
Kodak Wide Format Printing Solutions,Roxio
With thanks to: Kurt Young, Celestine Laporte, Jane Laporte and Josephine Bacon

Contents

Foreword

Digital technology has had a huge impact on all of our lives. Whether through the quality of digital television transmission, computers, or mobiles, it has enabled us to enter a world of immediacy, simplicity, and high quality. Yet when this technology began to transform photography, an art form that had remained relatively unchanged for nearly 200 years, questions were bound to be asked. In this book, you'll find the answers to most of them. We'll explore the principles behind digital imaging, look at what you need to get started, and find out how to take the best pictures and get the most out of them.

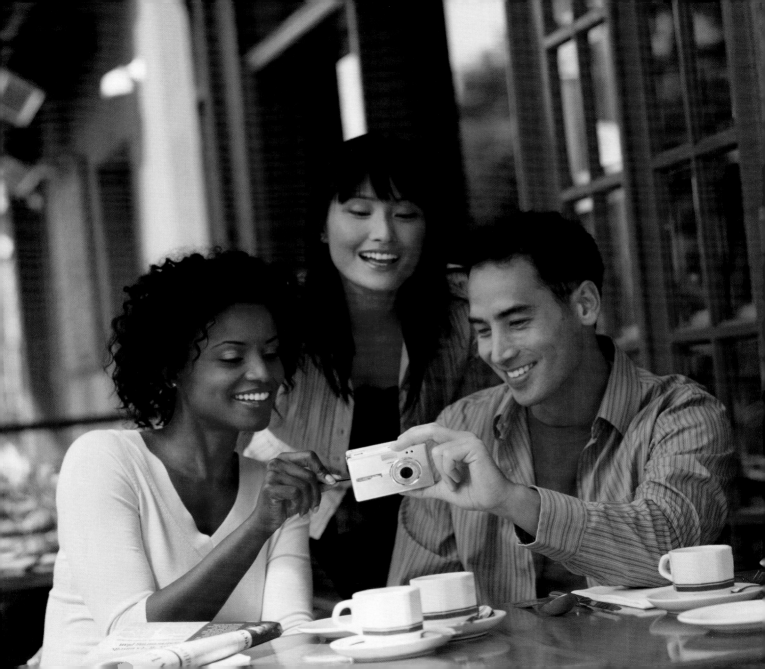

Introduction

We'll start by addressing some of the most basic questions. Exactly how can you take a picture without using any film? Why is the industry so obsessed with the number of megapixels? More importantly, what are they anyway? We take an overview of the digital process, look at its advantages over conventional photography and the exciting range of possibilities that it can offer.

Photography is just one of the many areas that has been forever changed by digital technology.

Why go digital?

The first digital camera compatible with a home computer entered an amazed market-place in May 1994. Called the "Apple QuickTake 100", and launched in Tokyo, it resembled a large pair of binoculars.

Old-fashioned view camera

Up-to-date professional SLR

It was much bigger and more expensive than most of today's digital cameras, costing just over £500. Since then the price and shape of digital cameras have changed dramatically and it is now possible to buy a basic digital camera for under £8.

Over the past decade the dominance of digital photography has become far more evident. Like video-tapes and vinyl records, a newer rival has overtaken film photography. It is unlikely that film photography will ever disappear completely as some professionals and enthusiasts prefer the qualities of film. It would be misleading to state that digital is ultimately better or worse than film, as there are advantages and disadvantages to both. Nonetheless, as the price of digital photography drops and the quality improves, digital imaging is firmly establishing itself as the dominant consumer market force.

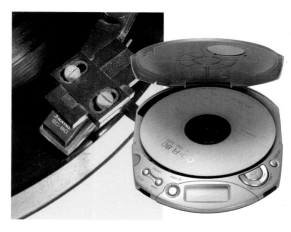

The advantages of digital imaging

✸ With digital technology you can view your results straight away and do re-shoots if necessary.

✸ There is no expense on film or processing.

✸ The price of digital technology is continually dropping.

✸ The quality of digital cameras is continually rising.

✸ It gives you greater flexibility to print pictures or transfer them electronically.

✸ You have more control over the final image.

✸ You don't waste time and money printing poor images.

✸ You can share images with others via email.

✸ Storage of images on a computer requires less physical space then a stack of traditional photo albums.

Delete badly framed images

No expense on film

Viewing images via a monitor is easy

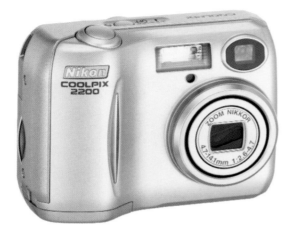

Digital camera (left). Conventional camera (right). The structure of the cameras is almost identical

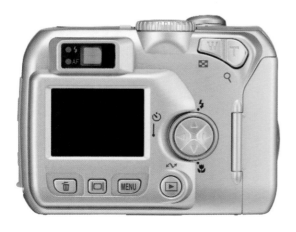
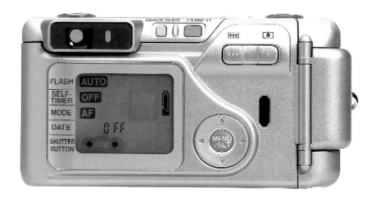

Digital camera (left). Conventional camera (right). On first glance they look very similar—however, the LCDs have very different functions

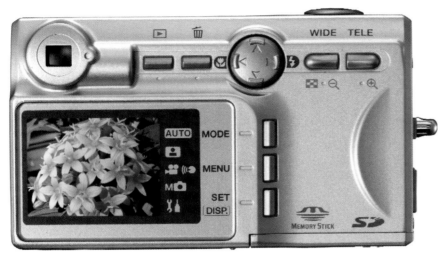

The LCD has revolutionised the way we take pictures

To anyone who is used to using a conventional film camera, initially, a digital camera will not seem that different. Generally, manufacturers have been keen to make digital cameras look as similar to film cameras as possible, so as not to intimidate potential consumers. The main differences between the two are the liquid crystal display (LCD), which many digital cameras have mounted on their backs, and their colour—the vast majority, of digital cameras are silver, rather than black. The other big difference is their size. The dimension of a roll of film has always restricted the ability of camera manufacturers to make very small cameras. With no such constraints on the digital camera, manufacturers can make cameras far sleeker and lighter than ever before.

However, it is inside the camera where the biggest differences lie. Let's now take a look at what digital photography is all about.

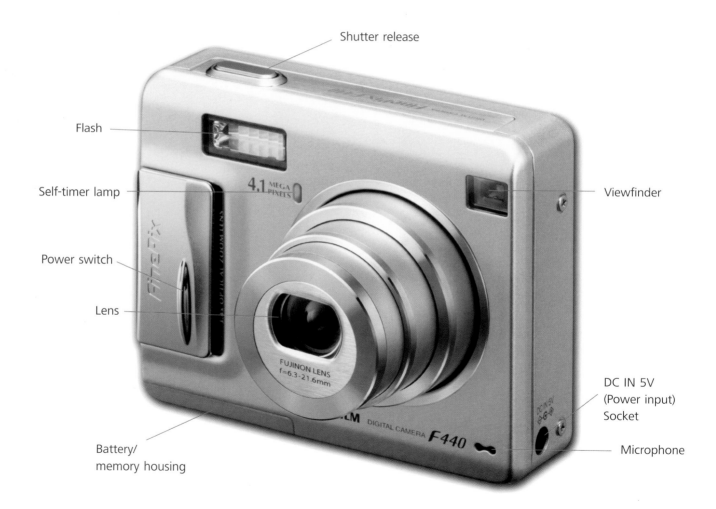

Shutter release

Flash

Self-timer lamp

Power switch

Lens

Battery/
memory housing

Viewfinder

DC IN 5V
(Power input)
Socket

Microphone

4.1 MEGA PIXELS

FUJINON LENS
f=6.3-21.6mm

DIGITAL CAMERA F440

Anatomy of a digital camera

Shutter release
Depressing this button enables you to capture the image. Digital cameras have electrical, as opposed to mechanical shutters.

Viewfinder
Not all digital compact cameras have a viewfinder. Looking through the viewfinder will allow you to compose the scene you're about to shoot.

Power input socket
Some cameras allow you to save your battery power by letting you plug the camera straight into the mains.

Microphone
Voice memos or soundtracks can be added to pictures or video footage.

Battery
The power source of the digital camera.

Lens
Essentially the lens is the eye of the camera and its quality is one area that makes a big difference to the finished image.

Power switch
This button turns the camera on and off. Due to the complicated software inside the camera, there may be a delay between switching the camera on and it being ready to take a picture.

Self-timer lamp
The self-timer lamp is a visual countdown by which you can judge when the shutter is about to be clicked.

Flash
This produces a powerful burst of light when required. The strength of your flash can be adjusted.

Memory
Your images are stored on the memory card. These devices vary in storage capacity and design. Cheaper models have on-board memory.

Whilst not all of the cameras available share exactly the same features, certain standard items will be present on all models.

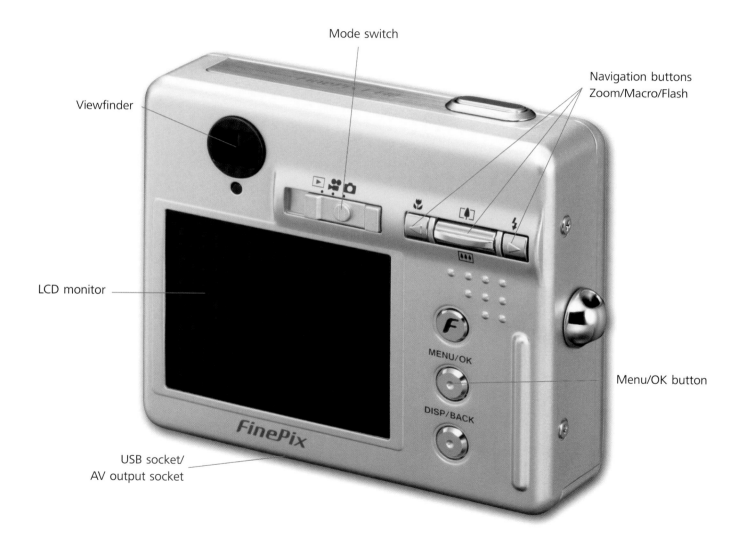

Mode switch

Navigation buttons
Zoom/Macro/Flash

Viewfinder

LCD monitor

MENU/OK

DISP/BACK

FinePix

Menu/OK button

USB socket/
AV output socket

Mode switch

The mode switch allows you to select exactly what you want to use your camera for, whether it is for still images, shooting video footage or reviewing and deleting photos.

Zoom control

By pressing this button you'll be able to get closer to your subjects without having to physically move. Zooming out will allow you to capture more of the scene.

Macro mode

This is the function to select when you want to take close-up shots. If you are planning to take lots of macro shots, you should check out the cameras range before purchasing.

Flash mode

Although not everybody realises it, on many compact cameras you can dictate the intensity of the flash. You may have the choice of two or three different settings to cope with various scenes. This facility will also allow the user to stop the flash from firing.

LCD monitor

The liquid crystal display (LCD) is similar to a very small television screen. This is the most noticeable aesthetic difference between conventional and digital cameras. The LCD allows the photographer to preview and review images on a compact camera. It also provides the user with the menu for the various modes and settings. However, the LCD puts a massive drain on the battery power.

The menu/OK button

Each time that you select a new setting on your camera you will have to confirm your choices by pressing the OK button.

USB socket/AV output socket

This is where you connect the USB cable when you want to link your camera up to various other peripherals, such as a computer or a printer. On this camera there is also a port for an AV cable. This can be used to hook your camera to into the back of a VCR so that you can view your images on a television set.

Select a camera with modes and features that appeal to you. New features are being added to cameras all the time.

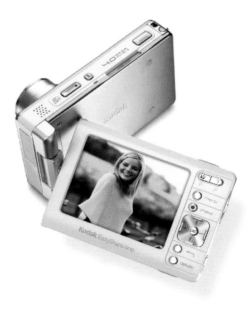

What really lies at the heart of digital imaging? And how is it possible to take so many photographs before running out of space?

What replaces film in the camera?

Most of us know the basic principles of photography. In its simplest terms light passes through the lens into the camera and the resulting image is recorded onto the film, a procedure that has remained relatively unchanged since 1826.

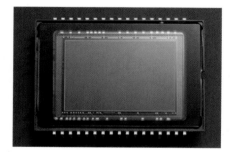

Digital photography substitutes the film for a Charged-Coupled Device (CCD). The CCD is a light sensitive conductor made up from millions of small light sensors, known as picture elements or pixels. When light comes into contact with the CCD, an electrical charge is created. This electrical charge is converted into different colours. The CCD captures the scene electronically to produce an image. The number of pixels that a camera has will have a direct effect on the quality of the image it can produce. However, there are other factors that affect this, too.

Size matters

The dimensions of the CCD will also determine image quality. The larger the CCD the more pixels it can have. The CCD is a very expensive element of a camera. Manufacturers will try to keep the size of the CCD relatively small, but cram in lots of pixels.

CCDs come in various shapes and sizes

This can result in poor quality images. Larger memory devices are found at the top end of the camera market. Unlike film, you never have to change the CCD, because it is built into the main body of the camera.

The great megapixel debate

Since the advent of digital imaging, questions around pixels and megapixels have been raising their heads. How many pixels are required to print good quality photographs? What are effective pixels as opposed to ineffective pixels? What is a megapixel?

A high resolution image at 5.0MB

A medium resolution image at 3.0MB

A low resolution image at 1.0MB

Dealing with the last question first—a megapixel is made up from one million pixels. Pixels are calculated by counting the amount of pixels that run vertically and horizontally. Most cameras allow the user to adjust the number of pixels used to take an image, so a camera that boasts 5.0 megapixels at its top range can also shoot at 1.0, 2.0, 3.0, or 4.0 megapixels. The more pixels you use for a shot, the more memory and power they use, so on the highest setting you will not be able to take as many images as a lower setting. Only the "recorded" number of pixels are used to take a picture, these are effective pixels. Only take notice of the effective pixel count. If you intend to print your photographs, it is advisable to to use as many megapixels as possible for the best result. However, if only viewing on a monitor screen, save memory and power by selecting a reduced megapixel count. If you don't know how you will use your images, set the pixels high, this will give you greater flexibility if you do get a top shot.

Memory storage

Once the image is captured, it is filed and stored onto a memory device. These devices are often referred to as 'media' and normally come in the form of small cards. Most cameras have removable memory cards where all of the information about the image is held.

Once your images have been captured on the CCD they need to be stored somewhere. The number of pictures you can take depends on the size of your images and your memory.

Image files are very large compared to the data contained in most text files. This is because the image file has to record the many different elements that make up a picture such as colour, tone and contrast. Cameras at the lowest end of the market have a storage device that is built into the body of the camera. With this type of camera it is not possible to boost or upgrade the existing memory. Once the memory device is full you will not be able to take any more pictures, unless you empty the camera's memory. Even small memory cards are usually very robust and capable of being used to store millions of images over the years with no detrimental effects.

Right: In terms of memory storage, the bigger the better

File formats

The images are captured on to the memory card and you can save your photos in various different formats. It is important that your images are saved in files that will allow you to work with them the way you want to.

JPEG

The most common file for digital images is the Joint Photographic Experts Group or JPEG, as it is more commonly known. This format is ideal if you intend to email your images or display them on the internet. The JPEG file compresses the images to make their size more manageable, allowing a relatively high number of shots to be stored on the card. Unfortunately this reduction in size means that some of the captured data is lost, this system is known as "lossy" compression. Whenever the JPEG is resaved some of the image quality is lost. Some cameras allow you to select the quality of the JPEG compression to normal, fine or super.

TIFF

If retaining quality is important to you, and your camera allows you to do so, you should consider saving images in a Tagged-Image File Format (TIFF). Although this system compresses the image, it will retain the quality. This format is a larger file format than JPEG, so it will take longer to download images. It is the preferred format for publishers, though some home computers will not be able to open these large files without additional software.

RAW

As the name suggests, this format saves all of the image data in its raw and uncompressed state. The camera's software does not interfere with the data and this is a useful format to use if you intend to manipulate your images using computer software.

GIF

This acronym stands for Graphic Interchange Format. This is a moderately compressed file that is best suited to the internet. Part of its appeal and popularity is that the GIF is easy for computer programs to interpret.

PNG

While nowhere near as popular as the RAW, JPEG or GIF files, the Portable Network Graphics file does have its fans and is gaining popularity. Referred to as "ping," it was designed as a replacement to the older GIF. It builds on the strengths of the GIF and takes things a stage further. Part of its appeal lies in the fact that it can be compressed without a loss of quality, and does so better than a GIF.

This simple-to-use file is compatible with both Apple Macintosh's and Window systems. The file can also be saved or restored with no degradation to the image quality.

Linking your camera to a computer

A new digital camera should come with the cables and leads required to connect it to a home PC or Apple Macintosh, and CD software that you can download onto your system. This will enable your computer to recognise your camera when they are connected.

Above: Use a FireWire or USB to transfer data

Below: Downloading images to your computer increases your options

Most new computers will already have a software package installed that will automatically prompt the user and guide them through the downloading process.

USB

This is the most common method that domestic users use to link a camera to their computer. The Universal Serial Bus (USB) port is usually located at the back or side of the computer on a PC, and inserted into the keyboard or hard drive of a Mac. One end of the download cable plugs into the computer and the other end into the camera. This is a very effective method for transferring images.

FireWire

If speed is important to you, you should consider the FireWire system. It also goes by the less catchy name of IEEE1394. It offers a very high-speed transfer connection. Not all cameras can support this system and, if you don't have an up-to-date Mac or a compatible PC, you will have to invest in a new port. Bluetooth technology has also entered the market to offer wireless image-transfer. Although this is convenient, as it allows images to be transferred without using any wires, wireless transfer is not yet as fast as hard wire systems.

Some cameras also allow you to reverse the procedure and upload images from your computer onto your camera.

Displaying your picture

There are many ways in which to view and display your image. You have the freedom to select a method that suits your situation.

Once an image has been stored you have several options regarding what you can do with it. You may decide to print the image to produce a conventional photograph.

If you don't have access to a printer, most photographic shops and a growing number of retailers will print the images for you from either your camera or memory card. Another option is to print the pictures yourself at a self-service kiosk (see Chapter Six) that you'll find in many retail outlets. This can be done very easily and you do not even need a computer to do so. Alternatively you can download your images onto your computer, where you can edit the images, email them or display them on a web page. Cheaper cameras tend to offer fewer pixels than more expensive ones and, as a result, the images that they produce may not be of good enough quality to print.

Some retail outlets provide digital imaging facilities

Your camera can double as a photo album

Viewing your images

Once the images are downloaded you can then store them on the computer system's hard drive or transfer them onto a CD or DVD, if you have a CD/DVD writer. This is a good idea if you want to free up your computer's storage space and also for backing-up images.

You can view your images on your computer monitor and then edit, email or just delete them. It is a good idea to label and group the image files together either by date or subject, so that they can be quickly and easily located on your system at a later date.

Getting Started

At first glance, it looks like there's a bewildering range of new, sleek, and stylish digital cameras available. In the following pages we'll examine the most popular types of digital camera in the marketplace and establish the criteria that should be considered for making the right choice for you. We'll also take a look at the rest of the equipment that you'll need to get started.

Establishing your needs

It's a good idea to think about what subjects you're most likely to want to photograph. Will you use your camera mainly to shoot pictures of landscapes, portraits, still life, family gatherings, or action shots?

Or perhaps you'll be shooting a mixture of subjects. Thinking about this and what you want to spend will go a long way towards establishing the type of camera that will suit your requirements. It's also helpful at this stage to have an idea of what you intend to do with the images once you've captured them. Will the pictures be emailed to friends, transferred to a website, made into prints or, perhaps, published in magazines and books?

When handling a prospective purchase you need to know if you feel comfortable with it in terms of its grip and weight. Ensure that the controls

are easily accessible and not too awkwardly laid out for your fingers. Personal recommendations from friends and reviews in photography magazines or on websites will also help you make your choice. Depending on your interest and enthusiasm for the hobby, you may want to invest in a camera system that can grow along with your confidence and ability.

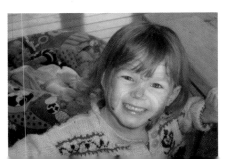

Point-and-shoot

These are entry-level compact cameras in terms of both complexity and price, currently starting from around £7. Point-and-shoot cameras tend to be fully automatic, giving the user little, if any, creative control.

This inexpensive, no-frills digital camera is an ideal choice as a first camera for children. If it proves successful, then invest in a more expensive model.

However that's not necessarily a bad thing, because they are simple to use and can produce some great results. As the name suggests, you just concentrate on clicking the shutter and capturing a scene. Also, because they are relatively inexpensive, you may feel less anxious about the camera getting damaged or lost. A point-and-shoot camera is the ideal tool to use for taking candid portrait shots. Their simplicity enables you to work quickly, giving you a better chance of catching your subject off guard.

One major disadvantage of these cameras is that they usually have a low number of megapixels—1.0 through 3.0 being the average. This affects the image quality and limits the printing possibilities.

However, if you are only intending to email images to friends and family, or display them on the internet, this will not be an issue. These budget tools also tend to have internal fixed memory systems, sometimes referred to as "fixed format" or "onboard memory," that cannot be upgraded, thereby limiting the available space. This means you will need to clear the memory at regular intervals. Another down side is that they are unlikely to have LCD screens or zoom lenses. Despite their shortcomings, point-and-shoot cameras are cost-effective, user-friendly, and certainly worth considering.

Praktica SlimPix

Semi-automatic compact

These easy-to-use cameras have proved popular with users, as they cover all the basics yet not too complicated for the beginner to handle.

By far the most popular of all digital cameras, they offer a greater degree of versatility and image control than the simple point-and-shoot cameras, allowing the user either semi-automatic or fully automatic operation.

These are good cameras for beginners, because they allow the user to have control over some of the more creative aspects of photography. A lot of these cameras will allow adjustment of the exposure, aperture, built-in flash or shutter speed, in fact, nearly everything you'll need to cope with a wide range of conditions. In general, the more you are prepared to pay for the camera, the more control you will have over the settings.

Most compact cameras have zoom lenses for greater flexibility, enabling you to get close-up shots without having to move position. Most mid-priced compacts will have an LCD screen, this can be used for composition purposes, or for reviewing images. Their relatively high megapixel count,

usually between 3.0 and 5.0, also means that the results can be viewed and enlarged without compromising quality. Depending on enlargement requirements, the resolution can be good enough to print and publish. Most of these cameras are also equipped with audio and video facilities, enabling the user to shoot short video films.

The compact camera market is the most rapidly expanding area of digital imaging and, as a result, compact digital cameras in this range are falling in price rapidly.

Pentax Optio 50

A wide choice of lenses and more advanced features make these cameras popular with serious photography enthusiasts.

Prosumer

This hybrid term refers to a type of combination camera, aimed at enthusiasts. Prosumer cameras target "professional consumers" —amateur photographers who want to enjoy some of the features of a professional camera but don't want the higher prices.

The lenses are normally better quality, and there is a wider range available than for compact cameras. The cameras are likely to have more advanced auto-focus capabilities. In addition, they may be able to accommodate a separate flash unit, for situations that require more powerful lighting.

While this is a growing market, the range of models is far smaller than for compact cameras and the prices are higher. However, as with all digital products, as development continues, prices will drop, making the cameras more accessible.

It is worth considering this range of cameras if you think you are likely to become a serious enthusiast, as the initial investment will pay off.

Finepix s7000

SLR

Single Lens Reflex cameras are at the top end of the market. Predominantly used by professional photographers, they have high specifications, some claiming 16.0 megapixels and the ability to shoot at eight frames per second.

This high-speed shooting capacity, as well as the interchangeable lenses, makes them an essential tool for the professional photographer.

Digital SLRs, combined with laptop computers, allow high quality images to be sent from all over the world to magazines and newspapers within seconds of the picture being taken, so are perfect for photojournalists. In addition to their better image quality, the other great advantage of digital SLRs is that their lenses are removable and interchangeable allowing for greater versatility.

We have all become accustomed to seeing the long telephoto lenses used by sports photographers and paparazzi, but the variety of different lenses and

advanced features available with SLR cameras also appeals to commercial studio-based photographers. The price of these cameras can be prohibitive to most amateur photographers, however.

Although the price tag often deters amateurs, these cameras are invaluable for press photographers due to the speed at which shots can be taken.

Nikon D2X

Waterproof housing

Underwater

As the name suggests, these specialist waterproof cameras allow the photographer to explore and capture underwater action. Waterproof housings are also available for some cameras.

Rotating lens or viewfinder

These flexible cameras allow shots to be taken from difficult angles at high or low levels, without the photographer having to move around too much.

Pentax 750z Optio

Nikon Coolpix 4500

Medium format

Favoured by commercial studio photographers, these cameras can also be seen out on location, usually as part of a wedding photographer's equipment.

Some medium format models allow the user to have up to 22.0 megapixels at their disposal. Thanks to the high quality results, most glossy fashion magazine cover shots are taken with medium format cameras. Digital medium format cameras are extremely versatile but their larger size and high price means that their appeal is limited.

Another camera used mainly by professional photographers, it produces very high quality results.

Hasselblad H1

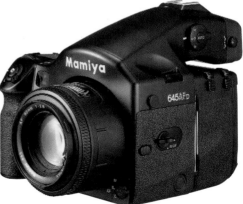

Top: Pentax medium format 645NII
Bottom: Mamiya 645AFD

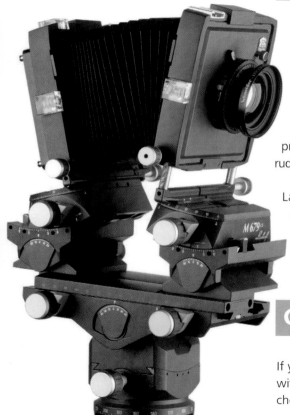

Linhof M 679cs

Large format

This type of camera is an unsophisticated, uncomplicated empty box with a lens attached at the front and a digital screen at the back. Inside, the technology has more in common with a pinhole camera than with any current digital compact camera.

Nevertheless, the large format camera is very much a top-of-the-range, professional tool, encompassing the rudiments of photography.

Large format cameras, or view cameras as they are also known, offer relatively few, if any, special features to the user. Their advantage for the professional is incomparable flexibility and quality. The prohibitive price tag means that they tend to remain in the arena of professional photography, however.

Photography for billboards is usually shot using large format cameras and then enlarged to the required proportions without loss of quality.

Camera and computer compatibility

If you are planning to use your camera with your computer, it is important to check that the two are compatible.

Most PCs loaded with a current Windows-based program will have no problems linking to a digital camera, but Apple computers may require additional software to link to some cameras. It is worth checking compatibility before buying any new equipment.

Different cameras at a glance

Point-and-shoot Light and often extremely slim, these little cameras are ideal for taking with you when you're on the move, particularly if you're travelling abroad and have concerns about losing or damaging your stuff. Cheap and simple to use, the user is not obliged to choose any modes or settings, as all of the thinking is done by the camera. These are the ultimate digital budget buy.

Semi-automatic compact This is the most popular buy and allows the user to be as involved as they want to be in the picture-taking process. There is a huge choice offering great versatility and many different features.

Prosumer This camera is aimed at the serious amateur who wants to have more control over the images than the straight-forward compact will allow.

SLR This professional tool is designed with longevity and robustness in mind. SLRs have interchangeable lenses and can accommodate a range of accessories. They will produce high-quality results but carry a relatively high price tag.

The difference in quality between high- and low-resolution pictures is demonstrated in the two images below. Low-resolution images are suitable for use on the internet.

Pixels in relation to resolution

It is important to understand the part that pixels play in the quality of the final image. It is widely believed that a 6.0 megapixel digital camera is the equivalent in print quality to a traditional 35mm film.

The quality of the final image is also dictated by the size of the CCD. Less than 1.0 megapixel and the pictures will only be good for emailing and displaying on websites. A 2–3.0 megapixel image produces decent 6x4 inch prints and 4–6.0 megapixels are publication quality prints up to 8x10 inches. Images of 6.0 megapixels and upward can be enlarged to 12x16 inches without too much loss of quality.

High resolution

Low resolution

Seeing the scene

The liquid crystal display (LCD) is the small screen on the back of most compact digital cameras. It displays a range of information from the camera menu system and allows the user to see the scene that is about to be captured.

Praktica DC2 4

The downside to LCDs is that they are a drain on the battery. Some compact cameras have adjustable LCD screens that swivel to enable the user to view the scene from a less conventional angle. Other cameras have a viewfinder as well and this can prove to be a very useful addition.

Small screens can be difficult to view, especially in strong sunlight, so composing through a viewfinder may be preferable in these circumstances. However, it should be noted that looking through the viewfinder of a compact camera doesn't give you the whole picture. You will not be looking directly through the lens, therefore you will not see through the viewfinder exactly what the lens sees. This is not a problem that is shared by SLR cameras, as the viewfinder shows exactly what is seen by the camera lens. However, on some SLR cameras you can't compose or preview a shot via the LCD.

Fuji FinePix

By altering focal lengths or by zooming in, you can get the picture you want by getting close up to elusive subjects or capturing a wide landscape without losing its impact.

Focal length

Technically speaking, the focal length of a lens refers to the distance from the subject to a specific area within the lens in which the image appears at its sharpest.

So, the focal length refers to what the lens will allow you to view. A short focal length gives the viewer a wide view or angle. By contrast, a lens with a long focal length enlarges a particular object in a similar way to how a telephoto or long zoom lens operates. So the longer the focal length of the lens, the closer you can get to the subject.

Zoom options

The zoom lens, though not always available on the least expensive cameras, has become standard on the majority of compacts.

Two different zooms are currently available—optical zoom and digital zoom. Optical zoom is preferable in terms of quality. The optical zoom uses the lens to enlarge the subject, in the same way that traditional cameras use telephoto lenses. There is no compromise in quality when using an optical zoom. Digital zooms, however, rely on software, not the lens, to enlarge the desired area. This process undermines the sharpness and can affect colour saturation of the image. Some camera manufacturers combine digital and optical zooms, in an effort to boost the strength of the zoom. When purchasing a camera, ignore the value of the digital zoom and concentrate on the optical zoom range.

Zoom range

You will often see 2x or 3x displayed on a camera, which indicates the power of the zoom.

The method for calculating these values is to divide the longest focal length of a lens by its shortest focal length.

For example, if the lens is a 35mm to 70mm, it will be classed as a 2x zoom, whereas a 50mm to 150mm lens is a 3x zoom. The longer the zoom range, the higher the price. Compact digital cameras tend to have 2x and 3x zooms; prosumer cameras can come with zooms as high as 10x.

The longer a camera's zoom range, the higher the price of the camera. Some prosumer cameras have 10x lenses and are, therefore, among the most expensive.

Praktica Luxmedia 4008-V2

Fuji FinePix A330 zoom

You can never have too much memory. Always go for the largest amount of memory that your budget will allow.

Don't forget memory

A spare memory card, often referred to as "storage media," should be at the top of your accessories list.

You can never have too much memory. The number of photographs that can be stored on a memory card very much depends on the quality of resolution you want. If you want to save space on your memory card or don't need to have the photos printed, take low-resolution images.

All but the least expensive cameras have detachable memory systems. Your new camera will come complete with a memory card, usually with a capacity of anything from 8MB up to 32MB. If you are taking high-resolution images, it won't take long to use up the memory on the card. An extra card or memory device that can store up to 256MB will enable you to carry on shooting. A number of such cards and devices are available.

It's important to check what is compatible with your camera, delete any unwanted images, and buy the biggest memory device you can afford.

The CompactFlash is, without doubt, the most popular type of memory card, and can be found in Kodak and Nikon cameras. It is not as compact as some of the competing memory cards, but it is relatively inexpensive, reliable, and very versatile.

SmartMedia is a thin and rather fragile memory card that is smaller than the CompactFlash. Currently it has a capacity of 128MB and is compatible with Olympus, Fuji, and Ricoh hardware.

A Memory Stick Pro has more memory than the CompactFlash or the SmartMedia cards. Sony cameras predominantly use this memory device.

xD-Picture Card and the CompactFlash memory card

Memory Stick Pro

Smart card reader

There may be times when you need to have your camera available to use, rather than have it tied up downloading images onto a computer. These devices allow you to download the images to a computer without the aid of your camera.

Just insert the card into the card reader and plug it into the computer via the USB port. A variety of card readers are available, but you'll have to check that your reader is compatible with your card. Some card readers are able to read several different types of card.

This xD-Picture Card is relatively new to the market. It is very compact, and has plenty of memory space.

The IBM MicroDrive has a greater memory capacity than the CompactFlash or the SmartMedia cards. MicroDrives tend to be compatible with the more sophisticated types of digital camera, they also tend to be one of the more expensive options.

Batteries

Digital cameras rely on electrical power in the form of batteries. Operating many of the features will use up battery power at a rapid rate. Running out of power can be frustrating, so ensure you always have a fully charged second set of batteries available.

In an effort to save energy, many cameras automatically switch to power-saving mode when left idle for a few minutes. It is always best to have rechargeable batteries for your camera as this will save money in the long run.

Traditional disposable alkaline-cell carbon-zinc batteries are best avoided as they are not designed to cope with the requirements of digital cameras. There are battery chargers that will run from car lighter sockets and some railway trains have facilities for plugging in a charger.

If given the choice, it is best to buy nickel-metal hydride (NiMH) batteries instead of the nickel-cadmium variety, as, due to their superior power reserve, they are much better designed to cope with the demands of a digital camera.

For maximum efficiency don't mix different brands of battery. Always load up with batteries that are the same, in name, voltage, and strength.

Some rail road trains have facilities to plug in a charger

Flash unit

While most digital compact and prosumer cameras come complete with a built-in flash, some SLR users will need to buy a separate, independent light source.

There will also be occasions, however, when the illumination provided by a built-in flash unit will not be adequate. Apart from offering more power, there are other advantages to flash units. Lots of flashguns have adjustable heads that can be directed at various angles. This means that it is possible to angle the flashlight so the light bounces off various surfaces, thereby softening the light before it hits the subject. In order to accommodate an external flashgun, your camera will need to come complete with a hot shoe connection.

An independent flash may be useful if you want to increase your scope.

Pentax flashgun

Metz 36AF-3C

Nikon Coolpix 5400 with flash open

A tripod can help you take a steady shot without camera shake.

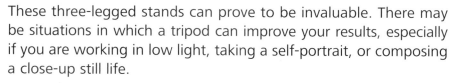

Tripods

These three-legged stands can prove to be invaluable. There may be situations in which a tripod can improve your results, especially if you are working in low light, taking a self-portrait, or composing a close-up still life.

The tripod can eliminate camera shake —the term given to the slight camera movement created when exerting pressure to depress the shutter. In certain conditions, this can cause the resulting image to be blurred. Sometimes, when shooting with a long, heavy telephoto lens, it can also be difficult to hold the camera steady. Tripods vary immensely in both price and quality.

As with most things, quality is very much dictated by price. The better tripods allow the camera to be secured in a range of different positions.

Most tripods are made of aluminum; this makes them light to carry but can compromise their stability. You should bear this in mind, particularly if you

have expensive camera equipment, as the tripod may be prone to fall over in windy or unstable conditions.

The platform on which the camera is attached is referred to as the head. These heads come in two versions, "tilt -and-pan" and "ball-and-socket." The ball-and-socket type allows the user unlimited movement of the camera in one mechanism. The tilt-and-pan version adjusts the vertical and horizontal movement separately. The centre post on which the head is fixed is also height-adjustable. The legs can also be adjusted to compensate for uneven surfaces or to elevate the angle of views. Modern tripods are light and easily transported, but if even these prove to be too bulky, there are alternatives.

Tripod

Suction mounts

Although somewhat limited in their usage, camera suction mounts are another source of stability, and can be attached to non-porous surfaces.

Monopod

As the name suggests, a monopod is the one-legged version of the tripod. Although it doesn't provide the same stability as a tripod, it weighs less and takes up less space. The monopod

Mini tripod

This is a shrunken version of the standard tripod. It usually comes with clamps that act like a vice to clip to the edges of flat surfaces.

has become a favoured accessory of long-lens paparazzi photographers, especially when they find themselves squashed tightly next to other photo-graphers alongside the red carpet.

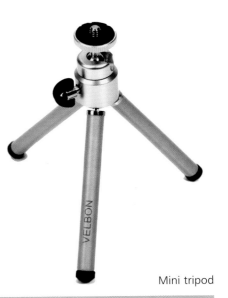

Mini tripod

Tripod tips

❋ The tripod should always weigh more than the camera that it's supporting.

❋ Tripods made from carbon fibre are highly recommended, as they are very sturdy and relatively light to carry.

❋ You can increase the stability of a tripod by weighing it down. If you are out on location, a bag filled with stones can be tied to the centre post.

❋ Make sure the tripod head has a good range of movement so that you can follow any action.

❋ Not all cameras have a tripod mount, so check the base of the camera before purchasing.

❋ More sophisticated tripods incorporate a tiny spirit level in the head so that you can always tell when the camera is perfectly horizontal.

A cable release can allow you to interact with your subject, rather than being stuck behind the camera.

Cable release

As well as using a tripod to reduce camera shake, you could also use a cable release. The cable release will allow you to activate the shutter without actually touching it.

These devices come in various lengths, allowing you to be as close to or as far away from the camera as necessary. Cable releases are most commonly compatible with prosumer, SLR, medium format, and large format cameras.

Sometimes the camera can act as a barrier between you and your subject. A cable release lets you step out from behind the camera, and this can be useful if you need to interact with your subject.

The more advanced version of a cable release is the remote controlled wireless device. Operated by radio control, the camera shutter is fired remotely via a handheld transmitter. This is particularly useful for wildlife photographers who don't wish to scare off their subject with their presence.

Cases and bags

After investing in expensive photographic equipment it is important to keep it protected. A number of inexpensive products are available to protect and carry your equipment.

It is a good idea to buy a case or bag with padding if you intent to take pictures while on the move. Aluminum cases will protect your equipment during transportation, as they come with foam inserts that can be customised specifically to accommodate your equipment. Many of them have combination locks, particularly useful if you are worried about security.

If you have a lot of equipment to carry, it is also worth investing in straps that will not cause shoulder pain after continuous use. Waterproof bags are also available and particularly useful on wet weather days or for using on the beach. Some bags and cases can be attached to the belt, which can be very convenient if you are travelling and want to have your hands free.

LCD screen, lens hood, and lens cap

It can be difficult to view the LCD screen in bright light, so use an LCD hood to eliminate intrusive glare. A lens hood will shade the lens, cutting out harsh light that may affect the final image.

The lens is the eye of the camera so it is important to protect it. Using a lens cap will preserve the quality and condition of the lens, preventing scratches and reducing dust. These inexpensive items can save you a lot of money in the long run, so they are certainly worth buying.

Camera shopping tips

* Read consumer camera magazines for the latest reviews.

* Search the internet for some of the best prices currently available.

* Make sure you handle the camera before buying it. If possible, borrow a friend's camera to see how you handle digital technology.

* Consider what you will be taking pictures of and what type of image quality is required.

* If given the option, select a camera with a large LCD screen.

* Buy a camera that won't limit your abilities as you become more skilled.

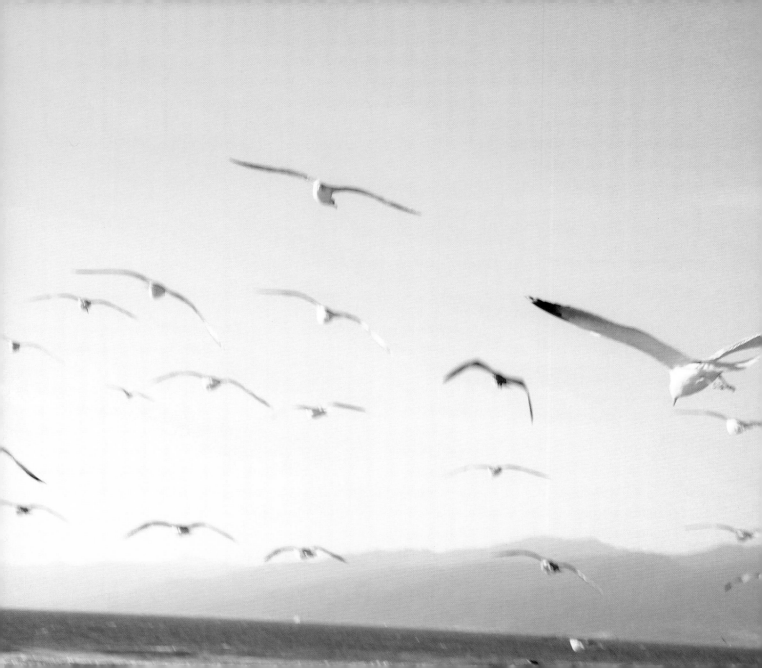

Camera Settings

Most mid-range compact cameras come with a clutch of pre-set programmes and modes designed to make taking pictures as easy as possible. The modes, most of which can be accessed via the menu, set the camera to cope with different subjects, surroundings, and conditions it may encounter. The number and complexity of modes available on a particular camera will vary according to the sophistication and price of the model.

New cameras come complete with all the accessories you will need to get started.

Setting up

Manufacturers are becoming increasingly aware that most of us want to be able to start taking pictures as soon as we remove the camera from its packaging. Most new cameras are ready to use immediately, complete with batteries and memory devices.

In addition, they will most likely also include a USB cable for easy connection to a computer or printer and a battery charger. There is an increasing trend for instruction manuals to be supplied in CD-ROM form, this can be an inconvenience if you want to start shooting straight away.

New digital cameras tend to take slightly longer than conventional cameras to power up and be ready for action. This is due to the vast amount of electronics that has to be up and running before you can take a picture. It is an issue that is being addressed by digital camera manufacturers.

If you are confident using a conventional camera, it should be fairly straightforward to convert to digital. It is worth remembering that you will not break the camera just by pressing the wrong buttons, but be careful not to delete any images accidentally. It's important to keep the instruction booklet handy as it will be useful if you want to use the more advanced features. It is also worth keeping the box, as the camera's resale value will be higher if it has its original packaging.

Manufacturers supply cables needed to power up your camera as well as a USB cable so you can download images onto a computer

Menu

The menu system allows
quick and easy access to
the camera's various
controls and settings.

The menu system on the back of your camera will allow you to access most of the camera's modes and features. By using the different arrows or prompt buttons you will be able to scan through this menu and set up your camera for different situations.

Familiarising yourself with the camera's menu system will allow you to obtain the results you are after quickly. Exploring the menu system before you start shooting will mean that you will be much more likely to get a candid shot or one of those "never to be repeated" moments.

The menu allows you to access many different modes. Just about every aspect and function can be controlled via the menu, and these include autofocus, exposure compensation, white balance, and the self-timer. Practice switching from one mode to another, perhaps from portrait mode to landscape, then sport. Change the settings via the menu, experiment with the white balance and resolution to see what effects they have on your images.

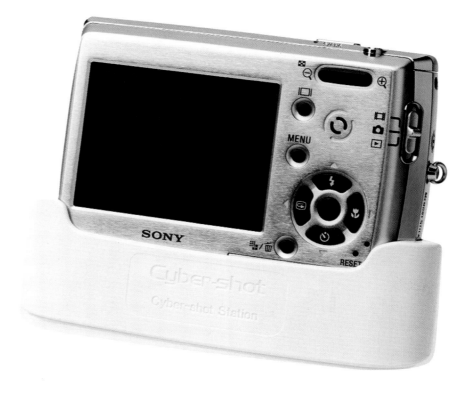

Don't be too static. Be versatile. Crouching down low, for instance, to get closer to the subject or to get a better angle, will improve your results.

Focusing

Compact cameras usually have some form of autofocus included within them. The cheapest compacts, though, have a fixed-focus lens, which means that everything within a certain range of the camera will be in focus, and this autofocus cannot be adjusted.

It is worth investigating how close you can get to a subject before the image becomes blurred and out-of-focus. This is a particularly important issue if you want to take close-up or still life nature shots. If the camera is more sophisticated, you'll observe how the focus shifts as you aim the camera at different subjects. See how long it takes for the camera to focus on each new subject. Press the shutter down halfway and see if the camera remains focused or has to refocus. If the camera allows it, switch the focus to manual and experiment with it. As you become more experienced, you will sometimes find manual focusing faster than using the automatic mode.

There are two different ways in which a camera will decide if a scene is in focus

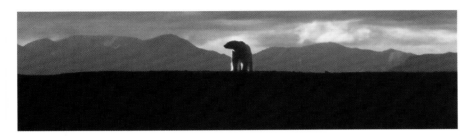

The polar bear is perfectly poised in the center of the frame. The camera lens had no difficulty in selecting the main area of focus.

or not. One method is when the camera sends out an infrared signal to the subject facing it. The camera calculates the time it takes for the beam to hit the subject and this enables it to judge how far away it is; it will then adjust its focus accordingly. The other method of focusing is similar to the way in which humans view things. The camera adjusts itself so that the different areas within an image are sharply focused. Unlike the infrared option, this method requires enough light for the camera to view the scene properly.

Most digital compact cameras use "centre autofocus," in which it is assumed that the photographer will compose the shot with the desired subject in the centre of the frame. However, problems arise if the subject is off-centre or, for instance, if the subject is shot through glass. A more advanced technique that some cameras use is called "multipoint autofocus," In this mode, the camera takes distance readings from specific areas in the image, and then calculates the best focus. This method is best to use if your subject is off-centre.

This picture has been overexposed, resulting in a washed out effect

Shooting directly into sunlight has bleached out this image

Exposure

By altering the exposure, it is possible to determine the amount of light that reaches the CCD. This will affect how bright or dark your images are. Too much light reaching the CCD will result in overexposed images, while underexposure means images will be poorly lit and too dark.

Overexposed colour images can result in scenes looking "bleached out." The autoexposure program on compact cameras should fulfill the needs of most photographers. In this mode, the camera will register the amount of available light by using its built-in light meter. Generally, the camera will take its reading from the center of the image, assuming that this is the main area of focus, but some use a bracketing technique, taking readings from different areas of the subject to get an overall average exposure and adjusting the shutter speed accordingly. More advanced cameras give the user the option of setting or adjusting these factors. Some cameras offer a shutter-priority mode, which allows the user to set the shutter speed, while the camera selects an appropriate aperture.

Exposure compensation lets the camera set the exposure level initially, but allows the user to adjust it either up or down during more challenging situations.

Histogram

The histogram is one of the most useful yet most misunderstood features of the digital camera. It is a graph that displays areas of the image that are overexposed or underexposed. This facility enables you to check that the exposure is evenly distributed across the screen and it is especially useful in difficult lighting conditions, such as bright sunshine.

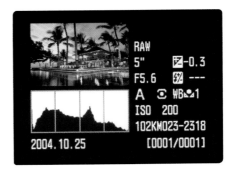

The histogram is a graph that shows how bright a scene is. By viewing it you'll see exactly how much light is hitting each area of the image

White balance

Cameras do not see artificial light in the same way as we do. Our eyes can naturally adjust when exposed to flash or tungsten light. The camera lens sees this light as a range of colours similar to that of a rainbow.

The white balance helps to correct this, by compensating for this discrepancy. Without this corrective device, some of the colour in the image would appear to be very unnatural. Light is traditionally measured in temperature, using the Kelvin scale. Normal light from the average domestic light bulb ranges from 2700°K to 3400°K, while bright sunrays register at 5500°K.

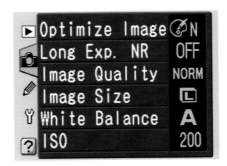

The white balance option is displayed on the LCD

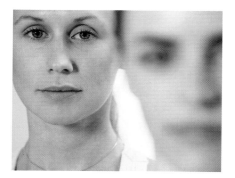

Aperture and depth

The aperture is essentially a hole that allows light to pass through the lens to the CCD. This hole can be opened or closed by various degrees, so, by adjusting the aperture you can decide how much light reaches the sensor.

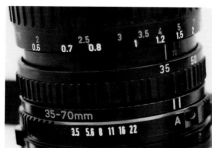

The aperture sizes are referred to as f-stops. The "f" stands for focal length. Generally speaking, these f-stops can be set at f/2, f/2.8, f/4, f/5.6, f/8, f/11, f/16, f/22. The smaller the f-number, the wider the aperture. Therefore, when set at f/2, the maximum amount of light is being allowed through the lens and, when it is set at f/22, the least amount of light is permitted. In addition to controlling the amount of light passing through the lens, adjusting the aperture will also dictate the depth of field. "Depth of field" is the term used to refer to the area of acceptably sharp focus in front of and behind the main subject of focus. Smaller apertures give a greater depth of field in which more of the surrounding area around the subject will be in focus, while wider apertures give a much smaller one. The distance from the subject is also an important factor.

Top: The woman in the foreground is deliberately out of focus so that the eye is drawn to the woman behind her

Middle: The numbers 3.5-22 represent the aperture settings

Bottom left: The aperture and the distance of subjects determine what is in focus

Bottom right: Selecting a wide aperture has created a very narrow depth of field.

Flash mode

Most digital compact cameras come complete with a built-in flash unit. SLR users usually have to buy separate flashguns that can be attached to the camera via a device called the "hot shoe" connection.

In automatic mode, the camera determines whether or not a flash is required. It does this by taking a light-meter reading from the subject. Flash photography is not solely the preserve of night-time or indoor picture-taking. Flash can also be a useful device to illuminate shadows when capturing images in natural daylight. This technique, referred to as "fill-in flash," is popular among many professional portrait photographers. A fill-in flash mode is now becoming increasingly common on digital compacts. It is also sometimes useful for overriding the camera's decision to use flash, especially when photographing close-ups or reflective objects. With fully automatic settings, it can be frustrating to find that your camera will not let you take a picture because it cannot function properly under certain conditions. Some flashes can be adjusted to low, medium, or high. If you are able to do this, you should experiment by shooting the same scene with the flash at different settings, so you can select the optimum result.

The average compact-camera flash is powerful enough to cover a distance of about ten feet.

A paparazzi-style shot is easy to reproduce with flash

Shutter

While the aperture determines the quantity of light allowed through the lens, the shutter dictates the amount of time that this will last. The slower the shutter speed, the more time the light has to pass through the lens.

Slow shutter speeds cause moving objects to appear blurred

A fast shutter speed is ideal for taking shots of moving objects, because it will let you freeze the action. Shutter speeds are measured in increments from 1/1000th of a second, the fastest, to half a second, one of the slowest.

Shutter priority mode, if the camera features it, will let you select the shutter speed you want, while the camera takes care of the aperture and exposure. The most popular cameras have modes that do all of the hard work for you.

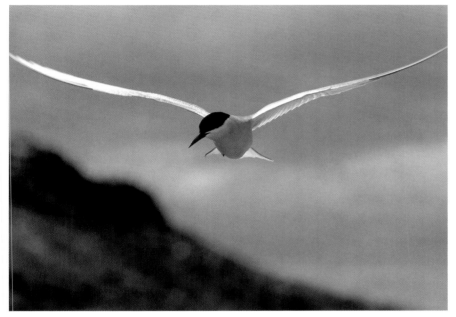

This bird has been frozen mid-flight by using a fast shutter speed and a zoom lens

One of the major problems with digital cameras is "shutter lag." This is the delay that occurs between the shutter being activated and when the image is registered. This is due to the time it takes for the electronic circuitry to absorb the information from the scene. It can be frustrating when a particular shot is lost due to this delay. The problem is less evident at the more expensive end of the market. Although the camera companies are addressing the issue, it is still quite a common occurrence in mid-range compact cameras. One way to get around the problem is to try to predict your shots by pre-focusing the camera and taking a rapid succession of pictures.

You can adjust the ISO speed to cope with difficult conditions such as low light, but fast ISO speeds will affect the image quality.

ISO

ISO stands for the International Standards Organisation and was traditionally used to denote the speed of a film. Slow films would have been ISO50, medium - ISO200, fast - ISO400, ultra-fast - ISO1600, and supersonic - ISO3200.

Different speeds were used to cope with different lighting conditions. Low light required a fast speed, while images taken in natural light could be captured using a slow ISO speed. Digital technology has retained the same principles, terminology, and ratings system, but, instead of referring to "film," the ISO speed refers to the CCD's sensitivity. With the majority of digital compacts you can't alter the ISO speed, but, if you can, you should experiment to see what difference it makes to the images. A very high ISO speed may result in a loss of detail and clarity. In film, the results are referred to as "grainy," while in digital this similar speckled effect is referred to as "noise."

The self-timer device allows you to be both model and photographer

Self-timer

The self-timer will enable you to be included in a picture. When using the self-timing device, after pressing the shutter there will be a short delay of a few seconds before the image is captured. This will enable you to participate in a group shot.

Some cameras even include an audible countdown warning so that you know when the photo is about to be taken. Allow yourself time to get back into position. The self-timing device is best used in conjunction with a tripod.

Red eye reduction

This is a recurring problem for many photographers, especially those using compact cameras. We have all seen pictures in which the subject's pupils appear to be blood-red, spoiling what might otherwise have been a really cute or glamorous picture.

The model's frightening red eyes distract the viewer from what is potentially a very strong image.

This is caused by the camera lens being located too close to the flash and is a direct result of the intense burst of light bouncing off the blood vessels at the back of the retina. Many digital cameras employ a system of dual flashes to combat the problem. The purpose of the first flash is to cause the pupils to contract. After a suitable delay, the second flash is fired in order to illuminate the scene. With the pupil now smaller, red eye is thereby reduced or eliminated.

This system is not foolproof, however, and if the model has their eyes closed or is looking away during the first flash the pupils will not contract and you could still be left with the problem. We'll be looking at other ways to combat red eye in Chapter Six.

With red eye reduction mode

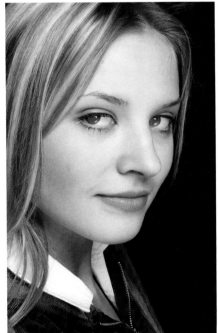

Without the red eye reduction mode

Portrait mode

People are by far the most popular of all photographic subjects. Digital cameras fitted with a portrait mode will select a shallow depth of field so that the subject is really sharp but the background is thrown slightly out of focus. It's a classic portraiture technique. In Chapter Four we'll have a closer look at the art of taking portraits.

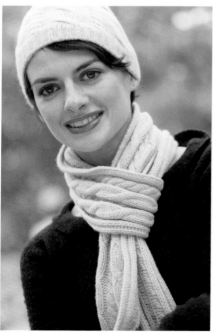

Try to find interesting or unusual angles, don't always go for the "square on" approach

Action setting mode

As the name suggests this is the mode to select before lining up a subject that is on the move. When the camera's set to take action shots it will automatically set a fast shutter speed in order to freeze any action. This mode is very useful if you are taking pictures at sporting events.

Keeping up with the action is easy in sport mode

Macro mode

Also referred to as "close-up photography," it is usually associated with nature and still life photography, though it can be used for many other subjects. Some cameras, when set to macro mode, allow you to get as close as an inch from your target.

Low-light mode

Sometimes called twilight mode or night scene, this should be selected when lighting conditions are poor. In this mode, the flash will automatically be activated. The camera will opt for a longer exposure to gain all available light, but you can improve the results by using a tripod.

Landscape mode

Unlike portrait shots, in which a shallow depth of field with a blurred background is common, landscape shots usually require a sharp foreground, middle ground, and background.

This is achieved by selecting a much wider depth of field, to reveal the full scope of the landscape. This mode can be used when photographing any expansive scene or even large group shots, and is not restricted to landscapes. Like all specialised modes, landscape mode will help you with the technicalities of photography. The real skill comes in knowing what will make a good picture and there's more advice about this in Chapter Four.

Firework mode

This setting comes into its own on 4th July, by allowing you to capture these colourful night-time events. In order to do this, the camera selects a very slow shutter speed and then sets the focus to infinity. It's always best to use a tripod with this mode to avoid the blurry results associated with camera shake.

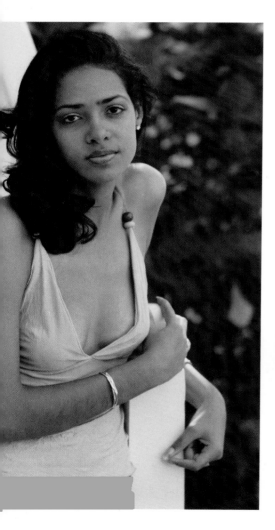

Rotate

The majority of digital compact-camera users take their pictures horizontally in landscape, rather than vertically in portrait format. The rotate mode will allow you to change your landscape format shots to portrait style and vice versa. This is particularly useful if you intend to view your images on a monitor.

Black-and-white

In the past, a photographer who wanted to alternate between shooting the same scene in monochrome and colour had to shoot using two separate cameras, one loaded with colour film and the other with black and white.

The invention of digital photography has now made that situation a distant memory. Some compact digital cameras allow the photographer to switch between taking black and white and colour images. There are some subjects that lend themselves particularly well to black and white photography, especially when you want to emphasise form and shape, without the distraction of colour.

Special effects

Most of the special effects associated with digital imaging take place at the editorial stage, after the picture has been taken, but here are a few of the more popular ones that are found on many cameras.

emphasising the lighting contrasts within the image.

Negative art
This option reverses the colour and light of an image so that the results are similar to a conventional negative film.

Sepia
Some cameras have the capacity to capture images in sepia tone, giving images an old-fashioned feel.

Solarise
This special effect gives your photos the look of a drawing. This is achieved by

Mode round-up

※ Make sure that your camera carries a good range of features; you may not want to use them constantly, but it's good to know you can.

※ Familiarising yourself with the different modes will allow you to select settings quickly and easily.

※ Don't feel that you have to go through the instruction manual from beginning to end, but keep it handy for easy reference.

※ Check to see if your camera has a "hot shoe" connection enabling an external flashgun to be attached.

※ See what sort of effects you can get by using non-recommended modes such as portrait mode for an action shot.

Picture Perfect

4

The list of possible photographic subjects is endless. In this chapter, we feature the most commonly snapped subjects, but first we look at how to hold the camera, composition, and lighting. The subjects covered include portraiture, wildlife, still life, landscape, sport and action shots, and photographing your pets.

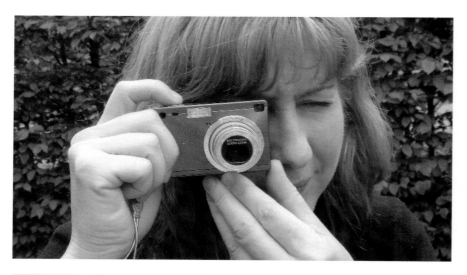
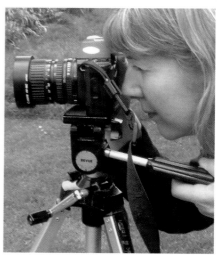

Getting comfortable with your camera

☀ The way you hold your camera will make a big difference to the quality of your pictures.

☀ It's important to grip the camera firmly and support it well, as this will reduce the possibility of camera shake.

☀ Practice holding your camera horizontally as you would for a landscape or group shot, then turning it vertically for a portrait format.

☀ Ensure that your fingers or camera strap do not accidentally obscure any part of the lens.

☀ Take care not to obstruct the flash. Use different stances in an effort to get the best shooting angles.

☀ Frame your pictures using the viewfinder and then via the LCD. If you've only used a conventional camera, getting entirely comfortable with an LCD may take some practice.

Far Left: The camera is being held horizontally and is supported underneath

Left: Sometimes it is best to place the camera on a tripod to keep it steady. This is a good idea if you're using a large SLR or you are worried about camera shake

Below: Hold your camera firmly in both hands but make sure you don't obstruct the lens or the flash with your fingers

Right: This vertical hold is generally referred to as portrait format

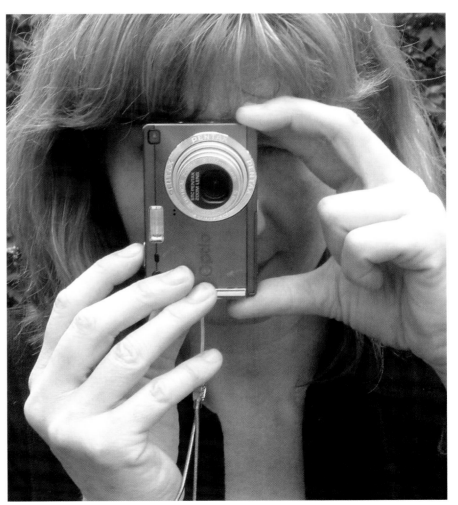

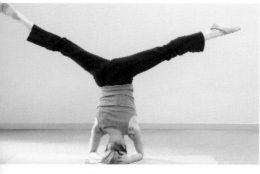

Above: This agile woman provides us with a symmetrically balanced shot

Below: Experimenting with different angles allows you to change perspective

Considering composition

Sometimes it can be difficult to know what separates an average shot from a good one. There can be a number of different reasons, including lighting, mood, overall style, or even subject matter.

Certain techniques will help you to improve your results. Thinking about how you want to frame and compose your shot will pay off in your results. Consider what you would like to highlight in your image, for example, is it an attractive face or a sweeping landscape? Are you looking to get a message across to your viewer or record a picture for posterity? Establishing why you are taking the picture will work toward achieving your goal.

Look for symmetry in a potential shot. This can be achieved by centering your subject matter. It is how most of us begin to take pictures and works particularly well when shooting images of buildings or landscapes. Think about what you want to include in a scene; it's often better to shoot slightly wider than you need and crop at a later stage for greater impact.

Look at whether the scene is best captured in a landscape or a portrait format. Don't just hold your camera in the horizontal landscape format for every shot. Select the format that best suits the subject and allows you to include or exclude certain elements. Anything that might distract the eye from your intended subject is best excluded. Allow your subject to take up most of the frame. If your zoom lens cannot cover the distance required, move in closer yourself.

Use certain objects to help frame others; composing your shot within a door or window frame will do this. Branches of trees, the arches of

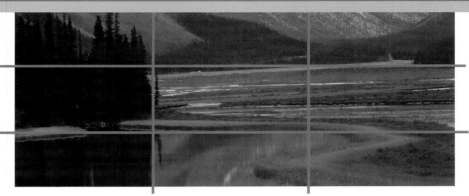

Left: This picture has been divided up to demonstrate the rule of thirds. Objects that appear on the lines or at the intersections are thought to be more pleasing to the eye

Below: The woman is framed through the shuttered windows

bridges, and other buildings can all be used to frame and enhance your shots.

When selecting subjects, look out for the lines that will demand your eye's attention. Lines that are naturally or artificially created—a winding river, the trees in a landscape, or the lines on a building or a train. Although most of us begin to take our photographs with the subject squarely in the centre of the frame, placing your subjects off-centre can work well. The rule of thirds is a commonly used device that helps photographers and more traditional artists to position their subjects. It relies on dividing up the scene by means of two equally spaced horizontal and vertical lines. Placing your main subject on one of the lines or at the intersections where the lines cross will produce good

solid conventional compositions. Look at some of your favourite photographs and imagine the lines drawn on the image. Does the composition comply with the rule of thirds?

Altering your position will give you different perspectives on a subject. Don't be too static, once you have taken standard shots look for new and slightly more unconventional angles. Shooting a person from below can portray them as dominant and powerful. See how the perspective and the perception change when you shoot the same person from above. Do the same thing with buildings. Take a shot of one building from another or if you're feeling adventurous, try taking a few shots while kneeling, lying on your front, or even on your back.

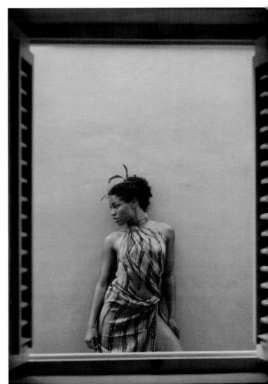

Lighting

Light and photography are inextricably linked. Light is the lifeblood of photography and being able to control and adapt it will help you obtain the results you want. The lighting can change the feeling and style of a scene in an instant.

Understanding different lights and their qualities is an important part of photography. By using light effectively you'll capture some stunning images.

Below: Morning light gives a much cooler look than the quality of light at other times of day

Most of us will have experienced the way in which other people's moods are altered by sunlight. Sunlight can lift our mood because it affects our levels of serotonin, and light can have the same influence on our images. Natural light can be frustrating to work with as we do not have direct control over the sun or its intensity. We can nevertheless learn to manipulate light so that it works in our favour.

The light cast in the morning is very different to the quality of light in the afternoon. Morning light is fairly "cold," producing a slightly blue tone. The midday sun can be strong and produce harsh and unsightly shadows for the photographer, while, at the close of day, the much warmer orange and yellow tones prevail that we associate with sunset. Observe your surroundings, look at the shadows cast in a room at different times of the day and year and how the light makes the objects in the room change colour. A light that floods into a room through a window pane is diffused and will offer a flattering illumination for a portrait. Placing a sheet of parchment paper over the window can further soften sunlight. Large polystyrene sheets can be used to reflect light onto your subject. This is useful when using a fill-in flash or to enhance low lighting.

If your camera has a detachable or adjustable flash unit you will be able to bounce the flashlight off a wall or ceiling. If, however, you are using a compact camera, your options are more limited. You can soften the

Left: Late afternoon sunshine provides a warm glow and a good backdrop

light from your flash by placing a piece of parchment paper or special photographic paper known as "diffusion paper" over the flash unit. This will produce a softer light and will be more flattering for some subjects.

Another alternative to flash is to use tungsten light. One advantage of using this type of light source over flash is that you can see exactly what your results will be. With the lighting fixed in place before you press the shutter there is less room for error. Various types of tungsten lighting are available. Studio lighting kits are expensive and often cumbersome, but they can produce very strong light that can cope with a wide range of subjects. An alternative to studio lighting is to use a simple spotlight to do the same job. Set up the

Above: Try different methods of lighting

shot and light it the way you want before shooting. Remember to turn off the camera flash, otherwise you may just swamp your subject with too much light and it will suffer from overexposure. This technique is good for still life shots. Having control over your light source removes some of the guesswork associated with flash photography and will provide some excellent results.

Professional studio lighting is cumbersome and can be expensive

Portraits

Whether in formal portraits or candid snapshots, our capacity and appetite for capturing images of each other never diminishes. Here we will look at some techniques—from overhead shots to adding props—for improving your pictures.

In general, most portraits are of the informal point-and-shoot variety and although these do not necessarily require too much technical expertise, with a little thought and planning the results will be significantly improved. You should think about what you want the subject to portray and whether you want to capture a particular mood or personality trait, or record a special occasion. Also consider whether there are any elements such as location, props, or clothing that will enhance the photograph. Be respectful of your subject's time and mindful of the image they want to convey. Everyone has a certain image of themselves in their minds and the model needs to believe that the photographer will flatter this image if they are to feel comfortable. In portrait photography, always treat the sitter with consideration. A certain amount of trust and confidence in the photographer's abilities goes a long way toward relaxing the model and producing good results. If possible, tell your subject what you are trying to achieve; with digital photography you'll both be able to view the images immediately so that alterations can be made. It's important to listen to any suggestions your model may make and try to lead the session without being pushy or arrogant.

Good communication skills are as much a prerequisite of a successful portrait photographer as are technical ones. Focusing on the subject's eyes is generally perceived to produce the best results, but you shouldn't be afraid to go against convention. If your camera

Below: This overhead angle provides a rather quirky view

Left: The stethoscope quickly and effectively establishes the subject's career and gives her something to do with her hands

Right: A different angle or adding a prop would have enhanced this image

Far right: The camera observes an intimate moment

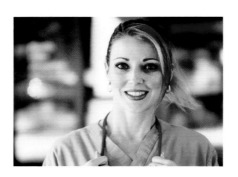

has a zoom lens you should use it to get closer to your subject. If not, get a close-up by moving physically closer to your target. Make a feature of certain aspects if you want to emphasis their effect and impact. Long hair, for instance, can act as a feature and a framing device in a photograph. The subject's hands, whether rough, delicate, or perfectly manicured, can also be a point of interest in an otherwise mundane picture. Models often don't know what to do with their hands and sometimes, even in a relaxed setting, a person's arms can look awkward. Folding the arms or clasping the hands, for example, can create a more natural result. Also, forcing your sitter to smile can look false. If the subject is relaxed in your company and with the situation, a smile will be naturally forthcoming. Better still, if you make the subject laugh, the resulting smile will be genuine.

The sun's rays are diffused through a glass window. Although people often think of using sunlight to light their subjects, a slow shutter speed and a tripod on a clear moonlit night can also produce some atmospheric results. Consider also using alternative light sources, such as candles on a birthday cake or the flames from a log fire. Try to think about a lighting source that will flatter your model and add to the image that you are attempting to portray. Move your

Perfect portraits

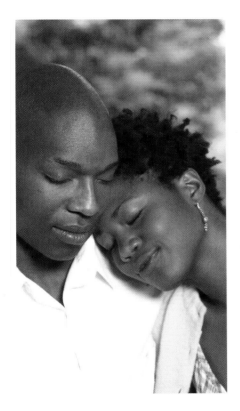

* A common mistake is to forget to pay attention to the background of the photograph when taking pictures. Though it is possible to edit out unwanted objects using software, it is always preferable to eliminate them at the picture-taking stage.

* Look out for any objects that appear to be "growing" out of your subject's head. Pay attention to any items in the foreground or background that may distract the viewer from your subject.

* Consider whether it's best to capture the scene in a portrait or landscape format. Try taking both of them to make sure.

* If there is a stunning backdrop, take advantage by positioning yourself or your subject appropriately.

* Clean and simple backgrounds usually work better than messy, cluttered ones.

* Select portrait mode if it is featured on your camera.

* Look for any unsightly shadows across the face, if necessary moving the model around to avoid them.

* Give the model an idea of what you would like them to wear for the photograph, indicating whether it is to be a formal or a casual sitting.

* Incorporate any props that may reveal more of the model's personality or add interest to the picture.

subject around to see how the lighting affects the final image. Strong, direct lighting can emphasise imperfections, while lighting your subjects from the side can be more forgiving and add depth to the image.

People are often more comfortable in familiar environments, whether in their workplace or at home

Combatting red eye

Red eye has been the bane of photographers' lives for many years. Pictures that were meant to show a cherub are ruined by demonic red eyes caused by the flash. Thankfully, with digital photography you are able to solve this problem at the editing stage (see Chapter Six), but it is best to address the issue even before pressing the shutter.

Compact cameras are particularly prone to red eye because of the close proximity of the lens to the flash. The first and easiest thing to do is to switch on the red eye reduction mode if your camera has one. This produces a short burst of light before the main flash is fired, so that the pupils have time to contract before the picture is

taken. If your flash allows you to do so, you should angle it so that it bounces off another object, such as the ceiling, before it hits the model, thus diffusing the light. Another solution is to increase the ambient light before taking the picture, as this will mean that the subject's pupils will not dilate so much.

Children

"Never work with children or animals." The usual maxim offered by those working in show business is probably a little harsh as, although photographing children can be difficult, it can also be very rewarding.

Their natural charm makes them an ideal photographic subject. On the downside, they often have short attention spans and can be uncooperative. There are many variables that have to be considered when taking pictures of children—their age being one of them. Waiting for a baby to produce the desired pose or smile can be a thankless task, especially if they keep crying or falling asleep, but whatever their age it is important to get them on your side. It is also worth noting that babies less than six weeks old will not yet have learned how to smile. Their happy facial expressions are more likely to be the result of trapped wind than inner contentment. Some babies may have blotchy skin as a result of frequent crying, so it is worth bearing in mind that black and white images are better at concealing these imperfections.

As with all portrait photography, it helps if you can build a rapport with your subject. In the case of children, bribery is often a useful tool, though this technique can also work with adults! Children also tend to be naturally curious and less self-conscious than adults, so the possibility of catching a candid portrait shot is greater with children.

Depending on the child's age, it may be possible to involve them in the picture-taking process. Show them what you are doing, perhaps by letting them take a picture of you with your camera and viewing the results. This will help to make it a more relaxed activity. With very young children it can be best to involve

Far Left: Children enjoy dressing up, so allow them to indulge in this and incorporate it into the photo session

Below: Playgrounds are a good location for child portraits as they can have fun on the swings and slides while you snap away

Right: Playing with simple props such as flowers or, in this case, a dandelion, keeps the subject occupied

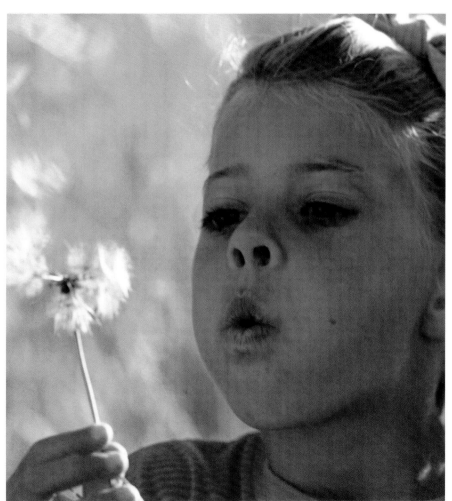

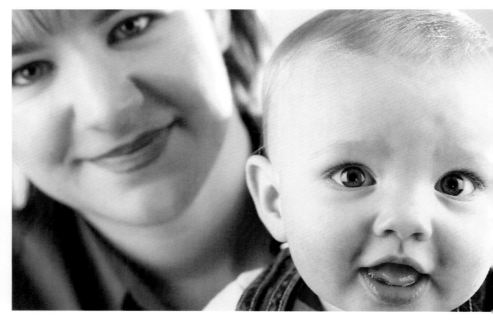

Sometimes it's good to enlist the help of a parent when tackling a children's portrait. The adult can hold or distract their child while you concentrate on taking pictures.

the parents in order to capture the moment.

Relaxation and familiarity are of paramount importance. When photographing babies and toddlers, favourite toys, bottles, brightly coloured objects, and interesting noises may grab and hold their attention. Children are likely to get tired or restless if the session is too long, so it's best to have a few short shoots rather than one long session. Many children enjoy dressing up and hats and sunglasses can all emphasise the fun element for them. Drawing with crayons and painting is another favourite children's activity and the vibrant colours in their drawings could become an added element in your photograph.

Using natural outdoor locations
such as a beach or local park
can provide good backdrops.

Below: This shot was taken with a long
zoom lens resulting in a shallow depth
of field throwing the background out
of focus

Right: The bark of the tree adds an
interestingly rough texture to the photo-
graph and contrasts well with the girl's
much softer features

Right: The good thing about taking a picture of someone riding a carousel is that you are guaranteed to have more than one chance at getting the right shot

Below: You need to be fit and agile in order to keep up with children and dodge the occasional snowball!

Opposite page: Adjust your shooting position and vary the angles to find a shot that works

Obviously not all children are the same, but the basics of child photography remain constant. It is best to use the minimum amount of equipment and not to get weighed down with complicated or cumbersome gear. You should also be alert and adaptable, as you'll have to work quickly if you want to capture kids on camera. Using a fast shutter speed will also allow you to keep up with the action and freeze any fast movement. Get down to the child's level both mentally and physically, as shooting at their eye level tends to produce more flattering results.

A long telephoto lens will enable you to shoot from a distance. They are useful for candid pictures so that your presence does not interfere with the child's natural activities. On the whole, it's easier to take a candid picture of a child at play rather than trying to get them to pose. As with most subjects, children feel most relaxed in familiar surroundings, such as at home, in their garden, or at a playground, all of which can be excellent locations for photographs. A formal studio setting is not necessarily the ideal environment for photographing children.

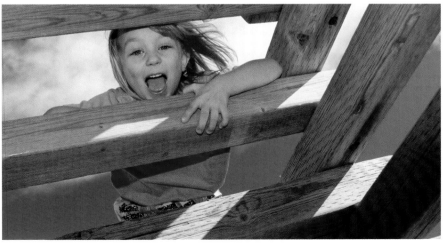

Tips for kid pics

✳ Shoot from a low angle—get down to the child's level, both physically and mentally.

✳ Interact with the child— show an interest in what they are doing.

✳ Be flexible and work quickly. Be patient and be prepared to take lots of shots in order to get the one picture you want.

✳ Make it fun by using props or letting them dress up.

✳ Use familiar locations, such as playgrounds or yards.

✳ Go for candid, relaxed shots.

✳ Use a fast shutter speed if the children are running around.

✳ Zoom in on your subject if you don't want to be intrusive.

Group shots

Large group shots can prove problematic. The most obvious issue is trying to fit everyone into the frame. Another common problem is trying to make sure that the photographer can see everybody's face. However, both of these difficulties can be overcome.

Firstly, although it may seem obvious, depending on the number of people in the group, arrange the shot so that the tallest are at the back and the smallest at the front, so that everyone's face is in shot. Set your camera to landscape setting if it has one. This will give you a very wide depth of field. In addition

Below: Although the pose has a fairly formal structure, the casual clothing helps to create a relaxed image

Below Right: These smartly dressed wedding guests create a more formal image

Don't always stick to pictures of faces when taking shots of people. The image left, for example, is an imaginative way of getting a great photograph.

to moving as far away from the group as you need to, consider lowering your viewpoint so that you are taking the picture from waist level.

Another common problem with group shots is that it is difficult to get everyone looking at the camera at the same time. Plenty of vocal encouragement, and even counting down from three to one before pressing the button can help. By taking a succession of pictures you'll be able to select the best one. Look at the way wedding photographers work, the way that they direct large groups and interact with them. A good one will communicate with the group and put themselves at the centre of the group's attention. Sometimes they will use stepladders or stand on chairs to improve their angles and squeeze the whole group into one shot.

Above: Shooting from a low level emphasises the power and dominance of these martial artists

Macro

Macro photography is the term given to photographing objects at close range. Plants, flowers, and insects are popular for this kind of image. Focusing on the intricate details of a subject can reveal some often overlooked but fascinating aspects.

Close-up images of flowers and plants can produce interesting and colourful pictures. It is always useful to have a good knowledge of your subject in photography and this one is no exception. Knowing when a certain species is in bloom will save you a wasted journey. It also helps if you know the time of day to photograph a petal at its best, as some flowering plants begin to close slightly in the afternoon, so you may need to catch them early in the morning for your desired result.

A good macro shot takes some patience to achieve. A tripod is an essential item, because small apertures and long exposure times are often required to capture minute detail. You can take these shots using natural light, but

using a fill-in flash will help with shadow details and can emulate sunlight. A cable release is useful to avoid potential camera shake. Also, be aware that the slightest movement of the flower or plant can spoil a potentially excellent picture. A gentle breeze can shift delicate petals, so it's useful to have a piece of card to act as a windbreak. SLR users can attach specialist macro lenses to improve their results, but these can be quite costly.

Many subjects lend themselves to macro photography. Don't just stick to photographing flowers and insects, try getting up close to a different range of subjects.

Still life

The term "still life" refers to the inanimate objects of a painting or photograph. It is a discipline that allows artists to study the form and lighting of a subject. The subjects traditionally used include bowls of fruit.

More recently, this form of photography has become popular in the world of advertising. Taking care of the minute details is the key element to taking a good quality picture of this type. In commercial photography, the objective is often to ensure that a brand name is emphasised or a product is shown at its best. Most of these images are produced in a studio where various factors, such as lighting, can be carefully controlled. In advertising, the photographer will generally be working to a fairly tight brief and may be aided by an art director.

As with all photography, care is taken in selecting the most appropriate background. A plain white background is often favoured because it produces a clean, non-distracting setting and allows the subject to take centre stage.

Although this method of photography is usually associated with professional photographers, it is becoming popular with amateurs wishing to sell items on internet auction sites.

Digital photography is the ideal medium for this activity, as the pictures can be easily transferred to a computer. It's best to keep the set-up simple for these pictures. You should use a tripod, if possible, or rest your camera on a solid structure to avoid unnecessary movement when the shutter is released. By taking pictures from various angles, potential buyers can get a good all-round view of the item and you can display the product in its best light.

You should be aware that if the object you are photographing has a shiny or

Left: Shooting these flowers against a plain white background allows them to stand out without distractions

Below: This rich, dark background complements the bottle and glass of red wine

reflective surface your reflection may appear in the picture, or flashes of light may be produced on the photograph. You may get a better result if you turn the flash off and use another light source, either natural or artificial, ensuring that it is not too harsh. Macro mode is the best setting to use for still life.

Landscapes

Landscapes can provide dramatic and inspirational images. A vast expanse of farmland dappled with sunlight or a cityscape bathed in a rich sunset can transfer beautifully to a photograph. Likewise, a mountain range can also produce dramatic and powerful results.

A few well-placed buildings or trees give the eye a focal point

When faced with a vast expanse of space, most photographers will try to cram in as much of the scene as possible. This is not always the best solution and you should take a few minutes to consider your options. Try to think about specific aspects that you find appealing about the scene or that would convey the essence of the landscape. Selecting a limited area or detail of a landscape will avoid the more obvious postcard perspective.

However, this is not always possible if there are access difficulties and you shouldn't ever endanger your safety just to capture an image. Always try to have a specific point of interest to focus on. Look at the scene, including the sky, through the viewfinder or LCD screen and then see how the shot would look with the sky excluded. By having a focal point in the foreground you'll add interest to your landscape shots.

Buildings, whether in the city or countryside, can add interest to your landscape

Left: This lopsided tree makes an interesting addition to what would otherwise be a boring landscape

Below: The people in the foreground add a sense of scale to a scene

This can be achieved very simply by shooting from a lower angle and focusing on flowers, rocks, or other such objects in the foreground of the shot. With the camera set to landscape mode, the entire scene will be in focus. Landscape shots lend themselves to wide depths of field. A lower angle will make the scene appear more dominant and imposing. Including a figure, either human or animal, somewhere in the frame, will add interest and provide a sense of scale. It can be difficult to get a feeling of perspective in a scene when there is nothing to measure it against. You could revisit the scene at different times of day or at different seasons to see how different it looks. The weather plays a major part in the impact of landscape photography. Different seasons can dramatically alter a particular scene. You shouldn't let unfavourable conditions put you off, as a good landscape and bad weather can produce a powerful image that others may miss.

Buildings

It is easy to take the architecture around us for granted. The buildings that we walk past, work within, or even live in can quickly lose their visual impact. Take another look at the structures that surround you so you can fully appreciate their appeal.

All buildings are constructed for a specific purpose, whether they are a place of worship, a residence, a railway station, or just a shack. When considering whether to photograph a building, walk around the structure to see if there is anything about it that you find particularly interesting. Discovering a historic building's significance can change your perception of it and allow you to view it in a different light. As with all photographic subjects, once you've secured any obvious shots that you may wish to capture, begin to assess the structure for any of its more unusual features. Instead of looking at the bigger picture, it is often a good idea to concentrate on the smaller one. Fine details, both inside and outside, can provide a wealth of photographic opportunities. Classic craftsmanship

and intricate detailing are often overlooked in a wide shot, but can make for an interesting feature in a close-up.

You don't always have to include the whole building in a shot. Focusing tightly on specific details or patterns and lines can also work very well. Modern glass-clad constructions reflect their surroundings, giving you two images in one.

Don't restrict your attention to historical architecture, contemporary designs can afford as many good lines and textures as older buildings. Many modern skyscrapers, with their outer glass cladding, reflect rich images of their surroundings, which may give your photograph a more interesting dimension - see picture above.

Pet pictures

It's not just our pet dogs that we like to photograph but, on the whole, a reasonably well-trained dog will be easier to take pictures of than a free-spirited cat or rabbit. Cats and dogs are the most photographed of pets, but all present particular problems.

Try to capture your pets in a relaxed environment

Keeping the animal occupied and interested will be a photographer's biggest challenge. In order to keep your pet's interest, introduce a reward system while you're taking the pictures. The animal will be more interested in a treat than it will be in posing for photographs. It is also a good idea to involve at least one of your subject's favourite toys in the session.

Setting your camera to an action or sport mode will allow you to keep up with any action. This will set the camera up with a fast shutter speed, thereby freezing any motion. It's best to avoid flash because you may alarm the animal. Shoot in the best light possible and preferably outdoors if you are aiming to achieve a natural-looking picture. Pets can be unpredictable, so being able to

adjust quickly to them is a great advantage. If you can incorporate the portrait session into a game or have someone else to help you hold your pet's attention, you are likely to achieve a better picture.

Make sure that your pet is well groomed, as unkempt coats or deposits in the corner of their eyes will detract from your pet's appeal. It's also best to get down to your pet's level, as it will make for a better angle. If your pet stays still on command or just naturally, set your camera to portrait mode and attempt to take some slightly more formal shots.

Pets can make fascinating subjects but you are likely to require an immense amount of patience and lots of treats.

Tips for pet pics

✳ Use something that will attract your pet's attention—food or its favourite plaything will usually suffice.

✳ If you have an energetic pet, start taking pictures after it has enjoyed a vigorous exercise session, as it is more likely to be cooperative and stay still for longer.

✳ Take shots continually to increase your chances of obtaining a special one.

✳ It's generally best to avoid flash and use natural light, but, if your pet has a black coat, then flash light will highlight the shading and texture.

✳ Check your pet's appearance before you begin, as a slobbering jowl is not a good look for your precious pooch.

Sport and action

This could give you the chance to combine two hobbies in one—photography and your chosen sport. It's possible to create some stunning images and gain valuable experience. Good sports photography requires precision timing and accurate anticipation.

The best photographers usually know a great deal about the sport that they are shooting, so they are better able to predict where and when the best action will occur.

Professional sports snappers will station themselves at one location, whether it is near the net on a tennis court or behind the goalmouth on a football field, so they are close to the action.

The essential requirements for sports shots are fast shutter speeds and light-ening-quick reactions, as the perfect shot may be gone in a split second. Some sports are inevitably easier to track than others; a leisurely game of bowls is less likely to leave you breathless than a hard-fought football game. However, both events will provide an observant photographer with some golden opportunities.

Always be aware of safety issues when shooting, don't ever put yourself in danger for a photograph

An overhead shot really gets to the heart of the action

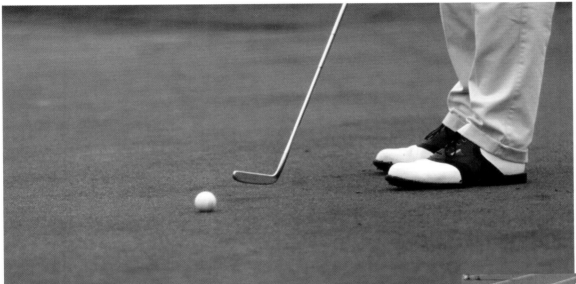

Sometimes it's better to look for the small detail and not just the bigger picture

Often this will not be their decision, as they are restricted in where they can set up at sporting events. Unless you are an accredited press photographer it is unlikely that you'll be able to gain access to the areas allocated to press at commercial sports events, which means that you will find yourself positioned with the spectators. However, this can have some advantages, as it will mean that you may have the freedom to

explore different viewpoints and features of a game without incurring anyone's wrath.

It can be difficult for even the most seasoned professional photographer to predict where the next shot will come from, but you can improve your chances of capturing it. If you are photographing a team sport, single out one player for a while, using your zoom

Pre-empt the action - go to the start or finish line of an event

It's easier to find prime locations when you know about the sport you're shooting

lens to follow the player around. Try to choose someone who is most likely to be in the thick of the action, such as a striker, a wide receiver, or a batsman. Look at their faces and see the anticipation in their eyes before they display a sudden burst of energy.

All sports have set pieces, whether it is a kick-off, a huddle, or the line-up at the start of a race. By becoming familiar with the sport you will be able to appreciate the structured sequence of events and pinpoint the relevant key features.

If your camera can accept different lenses try to use a long zoom lens and invest in a tripod or monopod for extra stability. Set your ISO speed fairly high, to at least 400. Digital cameras will set the camera up for your action shots, if you select the sports mode. When you're faced with ultra-fast sporting events such as motor-racing or a horse race, it can be almost impossible to keep up with the action as it rushes past you. In these situations, you still have a few options available. Set yourself up at one location on the trackside as close to the action as you can get. Set the focus on a specific point, but don't zoom in too much and keep your lens fairly wide and wait for the activity to come into frame. Take

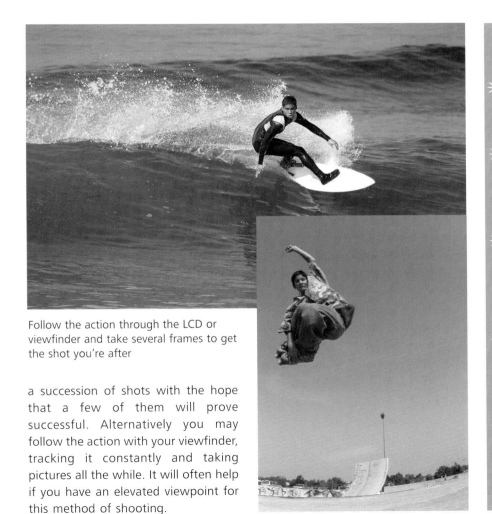

Follow the action through the LCD or viewfinder and take several frames to get the shot you're after

a succession of shots with the hope that a few of them will prove successful. Alternatively you may follow the action with your viewfinder, tracking it constantly and taking pictures all the while. It will often help if you have an elevated viewpoint for this method of shooting.

Sporting tips

* **Know your sport** - it will give you an idea of when to expect the action.

* **Positioning** - try as many viewpoints as possible to get the best look at the action.

* **Picking your subject** - choose a player who is likely to be in the thick of the action and follow them with your zoom lens.

* **Pacing** - focus on a point where the action is likely to occur and wait for it to fill your frame.

* **Take a many shots as possible**. It is better to have too many so you can delete the photos that do not work.

A mirror can help you to frame yourself

Self-portraits

Taking a self-portrait with a conventional camera is often a haphazard exercise. The biggest problem is one of framing, which requires a lot of time and effort to ensure that you haven't cut your head out of the picture or that you are in focus.

The advent of compact digital cameras has made self-portraits much easier. The most basic way to execute this sort of shot is to hold your camera out at arm's length, point it at yourself, and shoot. You'll quickly be able to work out where to position the camera and be able to discard unsuccessful images. Some digital cameras have a rotating lens or LCD feature, so you can view the picture while taking a photograph of yourself. If your camera does not have this particular facility, you could improvise by taking the picture while standing in front of a mirror. You'll be able see the image preview on the back of the camera because the LCD is reflected in the mirror. You can adjust your position to gain a better view. Another option is to put your camera on a tripod or other appropriate

Above: This is possibly the easiest way to take a self-portrait

surface and take the shot using the camera's self-timing device. This should produce more flattering results than the hand-held option, but depending on your distance from the camera, you may not be able to see the LCD or use a mirror to see a preview.

Big game is not always available to photograph, but interesting smaller species can make suitable subjects.

Nature and wildlife

As worldwide air travel becomes cheaper and more readily available, many of us are becoming more adventurous with our vacation destinations. Places we had once regarded as exotic and remote are becoming increasingly accessible.

Organised safaris in Africa or excursions to the Arctic provide safe opportunities for capturing big game in its natural habitat. If you are looking for some subjects to photograph that are closer to home, however, look no further than your garden, local park, or woods. Although you are unlikely to stumble across a cheetah or a polar bear, there are still plenty of opportunities to exploit. There are lots of smaller animals that we encounter everyday, from birds and squirrels, to foxes and even insects, all of which can provide a wealth of images. However, two major obstacles arise when indulging in this type of photography. The first issue is how best to sneak up on your subject before you scare it off, and the second is finding the best way to capture the assortment of wildlife photographically, once you manage to get close enough.

The art of stalking relies upon being able to blend into the background. Many of the most successful wildlife photographers don camouflage clothing and face paint in order to get close to the wildlife, while others spend

motionless hours in hides, purpose-built shelters, waiting for an opportune moment. It is not always necessary to go to these extremes, but it is worth employing some stealth tactics in an effort to get close to wildlife. Loud noises, sudden movements, or even reflective clothing can send a bird into flight or cause a groundhog to flee. So, it is necessary to progress steadily—and ensure that you have switched off your mobile! Slow, deliberate movements work best of all. If the sun is strong try not to cast long shadows over your subject to avoid disclosing your presence. However, being spotted by your potential model will not always cause them to scuttle away, as wild animals have a "comfort zone", the minimum distance they will allow you to be from them before they take off or attack. The range varies according to how confident the animal is and how much of a threat it considers you to be. A lot of animals rely on scent as much as, if not more than, sight to detect a threat or a possible meal. You could ruin a potentially good photographic opportunity by wearing too much perfume or aftershave.

Instead of the proactive approach, the alternative is to wait for the wildlife to come to you by positioning yourself near to an area where animals frequent; this could be a bird table, a pond, or just a secluded, peaceful area. If you have access to a cabin or garage, you could set up a feeding area nearby, so that you can hide away and remain unobtrusive. You could try leaving food out and then waiting for the action to start.

Far Left: Photographing an animal at full tilt requires a very fast shutter speed and a steady hand

Left: A local park can provide a wealth of opportunities if you keep your eyes open

Below: You don't always have to include the animal's entire body

Zoom lenses come into their own with wildlife studies, as they allow the user to capture a tightly framed image without being physically close to the subject. Selecting a shallow depth of field will help to reduce the impact of any distracting backgrounds such as unruly foliage or twigs.

Flash photography is not generally conducive to good wildlife photography, so try to rely on the available light sources, increasing your ISO and shutter speed to compensate if necessary. Make use of the natural surroundings by incorporating them into the picture if possible. An understanding of nature and a respectful approach should help you obtain some striking wildlife shots.

Night shoots

Some of the most beautiful and fascinating images are produced with virtually no light at all. Taking a picture at night without a flash may seem to be a rather futile exercise, but when you see some of the results, you'll realise that it's worth experimenting with.

Left: Slow shutter speed and a tripod ensured that this image was sharp

Selecting a good location is an important aspect of night-time photography. In modern cities there are very few places that are ever completely dark, as street lighting, car headlamps, and building lights all contribute to what is termed "light pollution." Nowadays it is only in remote countryside areas that total darkness can be achieved.

A tripod is an essential accessory if you intend to take some night-time shots, because the camera has to be steady during the long exposure required. A cable release will further reduce the possibility of camera shake. Select the twilight mode on your camera. This will automatically adjust the exposure, select a wide depth of field, and adjust the flash facility. The long exposure allows the camera to absorb as much naturally available light as possible.

The time of night will have a big influence on your resulting images, because, although at night the sky can appear to be a single expanse of darkness, there are certain differences in the colour of the sky, depending on when you take the photograph. If your camera allows you to experiment with the shutter speed and exposure, compare the different results. Another good exercise is to take the same scene during the day and at night and you will then be able to tell whether or not the lack of light adds something to the scene.

Above: This bridge is artificially lit

Right: You don't always have to wait until the sun has completely disappeared from view

Far Right: On a clear night moonlight can be used to good effect

Sun, sea, sand, and snapping

For some the only time they use their camera. It is inevitable that a beach scene will inspire people to take photographs, as the often clear sky and uncluttered lines provide ideal angles and clean backdrops for beautiful pictures.

Taking pictures on a beach can throw up specific problems. The large expanse of sea and sand can overwhelm a camera's light meter and result in a bleached out effect. Your camera's beach mode will overcome these difficulties by compensating for the strong reflections and balancing the light.

person with the sun behind them.

When you are seeking out memorable beach shots, don't take only the obvious pictures, but have a look around to see if there are any other elements of your surroundings that can convey something different about the scene.

One of the other problems associated with beach photography is that extreme sunlight can result in a great deal of unsightly shadow. It is of particular concern if you intend to take portraits. This is when fill-in flash comes into its own. Flash is usually associated with night-time photography, but it can also be a useful device in bright sunlight. By selecting fill-in flash on the menu you can combat the shadows that are often created when photographing a

Above: At first sight this may not seem like an obvious shot, but the girl's symmetrical pose and the clear background work really well

Left: Get down to your subject's level if a photograph warrants it

Left: The beach can provide good opportunities for candid photographs. Use a zoom to get in close

Below: The speed boat and inflatable banana give this picture a sense of fun

Below Left: A shot of a rock pool, a close-up shot of seaweed, or a distinctive seaside shell can all provide unusual abstract studies.

For a more conventional approach, try photographing a sunset. A deep, rich sunset will create a memorable shot. It isn't always best to place the sun at the centre of the frame, putting it off-centre and allowing something or someone to be the main focus of attention may create a more interesting image.

Seaside hazards

☀ **A beach scene can prove to be one of the most difficult and demanding environments for the everyday compact camera.**

☀ **The average compact camera does not cope well with the mixture of salty sea air and sand.**

☀ **Salty sea air has a tendency to corrode and prematurely age exposed metal parts.**

☀ **Splash out on a special waterproof housing for your camera if you intend to take lots of beach shots.**

☀ **Make sure you never leave your camera in direct sunlight.**

Man and machine

Automobiles and trucks are popular subjects for photographers. Car designers spend years developing all aspects of their vehicles, labouring over lines and detail to create alluring curves. Long bodies and low-profile alloys hint at the power beneath the hood.

Top: It's easy to overlook such small details but the fuel gauge has bold colours and strong lines

Below: This little statue is begging to be photographed

Look at the car's aerodynamics and see how the appearance of the car changes when viewed from different angles. Study the way in which light alters the colour of the paintwork. Some cars genuinely cross the boundaries between engineering and art.

It's not just the sexy super-automobiles that can make good subjects, everyday models are also worth considering. All cars are designed for a purpose whether they are a sports utility vehicle, a pickup truck, or a luxury cruiser. Each auto will have its own features and points of interest.

While modern cars may be more accessible, classic cars possess a certain charm and elegance. Many classic auto rallies take place all over the country during the summer months. A car rally will provide an excellent opportunity to photograph cars in "showroom" condition. Owners are very proud of their cherished models and will generally be flattered if you ask permission to photograph their pride and joy.

The simplest way to approach a car photo shoot, is to get some general all-inclusive shots. If the car has a good background, use it. Move yourself around to take advantage of the surroundings. Take fairly wide shots of the back, front, and side of the car, keeping your camera level with the vehicle. When you have secured a few general shots, it's time to get up close. Position yourself so that you can get some images that are not square on. This will add depth and dimension to

Top Middle: These furry dice say a lot about the car owner's sense of fun

Top Right: The simple colours and clean lines produce a pleasing image

Bottom: The car's blue and white paint work is replicated in the columns and the sky

your photographs. Fully lock the steering wheel so that the front tires are turned outward, and then try turning them inward to see which works best. Experiment with shots from different angles and elevations. The ground can make a good strong "background" when shooting a car from above, particularly if it contrasts strongly with the car's colour. If the car is a convertible, take shots with the top up as well as down.

Try to select specific details that pertain to the vehicle, for example the manufacturer's emblem, a cluster of headlamps, the wheels or even a large aluminum tail-pipe. Get inside the car and look for any special touches: chrome switches, a leather steering wheel, or intricate dials can make for less obvious car shots. Have a look at the engine, zoom in on one aspect in order to create an abstract image.

One of the attractive features of cars is their sleek lines, which draw the eye and their appealing shiny metalwork. However these highly reflective

Top: Some people really suit their cars. The cowboy and his truck are a perfect match

Bottom: This top of the range marque has its front wheels turned in to add interest and depth

surfaces can cause some problems for a photographer. A powerful burst of flash can be more of a hindrance than a help if the light rebounds off surfaces. Try switching off the flash and relying on available natural light. A large piece of white card or some aluminum foil can act as a reflector. If it is positioned just out of shot it can be used to throw light back onto the subject and lift shadows. Try to avoid getting your face or camera reflected on your subject.

Before you start taking pictures of a vehicle, ensure that it is clean. This may sound like obvious advice, but the camera will pick up on unsightly blemishes. Whilst it is possible to remove grim or dirt at the editing stage, it is always better to take the best image you can.

Reviewing Results

5

Perhaps the biggest advantage that digital imaging has over its conventional predecessor is immediacy. Only recently, we were taking photographs and waiting for days—sometimes weeks—before we could see if we had achieved the results we wanted. Now we no longer have to wait for days or rely on a third party to process our photographs; we can view the images straight away. Here we shall examine the various methods by which you can review your results.

LCDs allow you to show off
your pictures immediately

LCD

The most obvious and straightforward way of seeing the pictures you have just taken is via the LCD screen on the back of the camera. These screens vary in size, but larger ones allow you to see more detail.

You will have to switch your camera from shooting mode to a view/edit mode and then you should be able to scroll back and forth through the images by using the navigation controls. Many cameras will give you options for viewing the images. You can view each image individually so that one image takes up the entire screen. This is the best method to select when you are viewing an image for the first time. It will allow you to check the image for imperfections such as half-closed eyes in a portrait or poor lighting, so that you can set about re-shooting. Although many problems can be fixed or manipulated on a digital image using software, it is always best to try to get the best photo possible when taking the original shot. Another issue to bear in mind is movement. While it is possible to add blur to images, trying to remove it is a more complicated matter (see Chapter Six).

It is also possible to view several images simultaneously. Depending on the camera you have, you'll be able to view up to 16 images on your LCD at any one time. The pictures are in very small format and displayed in separate panels but this is a good option to use if you are looking through a set of photographs and want to select a particular image quickly.

You'll know the moment you've secured that special shot

Television

Viewing your photographs on your television set is very simple. Your TV set will need to have a video output jack and you'll need to have an AV connecting cable, which is usually supplied with your camera kit, to connect the TV to the camera.

It's important that you turn off both appliances before attempting to connect them. Different countries use different video systems, for example, in the United States, the National Television System Committee (NTSC) is the standard, whereas in the United Kingdom Phase Alternating Line (PAL) is used. The two systems are not compatible. So if you buy your camera abroad, you should bear this in mind.

View your images in widescreen luxury

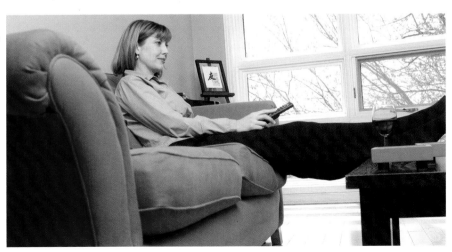

An AV cable links your camera to your VCR

Sit back, relax, and enjoy a slide show on your TV set

Downloading images

Not only has digital technology increased the number of photographs that we now take, it has also affected what we do with them. In recent years, there has been a growing tendency not to download or print images.

This is because many pictures are taken in low-resolution via mobiles and then emailed before being deleted. Digital camera users have more options available to them and their images will be of higher quality, both technically and aestheticaly. After using your camera for some time, you may wish to free up some storage space or edit your images, so you will need to download them onto your computer. In Chapter Seven, we'll look at how to download images if you don't have a computer.

Manufacturers have made the process of transferring your images very easy. Most cameras are now supplied with the necessary USB cable and drivers required for easy image transfer. Firstly, you will need to install the USB driver software into your CD-ROM drive. Some operating systems, such as Windows XP, do not require you to do this because they already have the relevant software installed. Remember that you will have to reboot your computer to complete the installation. When this is finished you can install any image transfer software that is supplied with your camera.

If you are using a PC or Macintosh that is less than five years old you are unlikely to need any additional software to transfer images. Windows uses a "Scanner and Camera Wizard" to perform this operation. Your system will automatically detect a new piece of hardware, when you plug your camera into the computer. It will then present you with a range of options.

Above: View your snaps on the LCD then download them onto your computer

Setting monitors

When you are reading or writing text displayed on a monitor, the quality of each character is of little concern. The monitor settings are selected in the factory and, while these are more than adequate for most needs, the settings ought to be optimised to view images.

Setting up your monitor so it will display images accurately will enable you to see clearly what you have captured. You can adjust the screen display settings via your computer's onscreen control panel.

Resolution can be increased or reduced, from 640 x 480 dpi through 1280 x 1024. You will need to set the monitor to at least 800 x 600, although 1152 x 864 would be a better option to start with.

You will also be able to select the colour quality and you should use the high 32-bit for a while. Software is available that will show you how to adjust your monitor for optimum viewing, by showing you how to alter contrast and brightness and ensure you have good colour calibration.

If the colours on your monitor do not match to the images you print, it's time to calibrate your monitor.

Above: Enjoy viewing your images on your monitor

Be safe, get back-up

✳ **Losing your photographs can be extremely annoying, so it's important to back-up the images on your computer.**

✳ **You can copy images from your computer's hard drive to a CD-ROM.**

✳ **Re-writable CDs and DVDs are fairly inexpensive to buy and very easy to store.**

✳ **If storage space is an issue and you require lots of CDs, house them in plastic sleeves, rather than the traditional solid cases, and store your CDs away from your computer.**

✳ **Buying a portable hard drive enables you not only to back-up your images but also to create more storage space on your computer.**

Creating files

The speed and ease of digital photography means that you may find you have taken hundreds of pictures in a very short time. It is very easy to become overwhelmed with the volume of images you are producing.

Therefore, it is best to organise your images into folders on your computer. You will be given an option as to where you would like to store the images.

You'll find there is a great deal of data that is captured along with your photograph. By hovering your cursor over any image you will see that, in addition to capturing the picture, your camera has also recorded the dimensions of the image, the time and date when it was taken, and the size of the image.

When images are downloaded they will already be identified, usually with a number, but it is best to rename them with a label including the location and subject to help you retrieve them at a later date. You can avoid confusion by opening a new folder every time you download a new set of images. Keeping pictures in different folders reduces the possibility of mixing them up.

Left: You can run through your image files and then simply click on the images you want to open

Compressing files

A great deal of data is encapsulated in a digital image. Many images include information such as the type and model of camera used. The files also retain all of the detailed elements required to create a photographic image.

Below: Image files being downloaded into folders

If you intend to transfer images over the internet, you may want to compress them to make them more manageable and reduce the transfer and downloading time. The essence of the picture is not lost and can still be accurately interpreted.

Various programs are available that will allow you to compress your files. For the PC there is WinZip and, for Macintosh, Stuffit. Some of the best file formats are BMP (only available for the PC), TIFF and PICT.

For sending images over the internet, a JPEG is the most compressed and most commonly used file format. The BMP and TIFF formats are good if you want to edit your images at a later date.

Millions of images are emailed across the world wide web every day. It is by far and away the world's most popular way to share images.

Emailing images

In the same way that digital imaging has transformed the quantity and quality of our photographs, the internet and email have transformed the way that we share our photographs. By attaching a picture in an email you can send it across the internet.

There will be a limit on the number of pictures that can be attached to an email, depending on the size of the images. JPEG and Graphic Interchange Format (GIF) files are convenient to send while other formats such as TIF and RAW take up more room. Although broadband is becoming increasingly popular, many people still use a dial-up internet connection at home, which means that download times for images can be very slow. Your Internet Service Provider (ISP) will have placed a limit on the file size you can send, so although many allow up to 250MB of storage space, you are limited by the size of file you can send— this is usually 5MB.

Emails can also have images embedded in them, though with increasing concerns about internet viruses there is a growing tendency for certain forums and systems not to accept attachments or to block out images embedded in the message text.

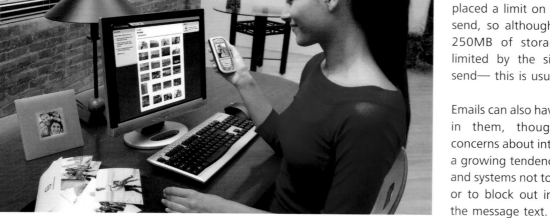

Formatting memory cards

The memory card that is supplied with your camera should be ready to record images, though sometimes they need to be prepared beforehand—known as formatting or initialising. If for any reason you wish to reformat a card, this will erase any stored data.

Formatting can be performed through the camera, by inserting the memory card and selecting the memory tool via the menu and then using the navigation buttons to find the Format option. It is best to plug the camera into the power socket during this process, so that the camera does not shut down. When the process is completed your storage media will be ready for use. Many cameras are equipped with safety locks so that you can't accidentally re-format a memory card and it's a

good idea to use this option if it is available. It is also worth noting that you should always ensure that the camera is turned off before removing or inserting a storage device.

Formatting cards simply means "preparing" them for storage. It is also referred to as "initialisation."

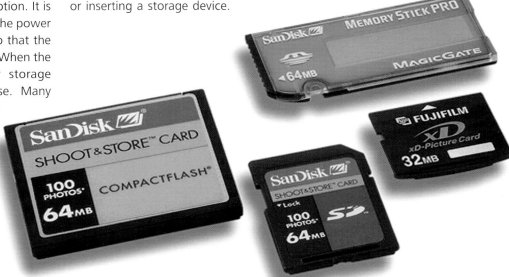

A range of memory cards is available on the market—if purchasing additional memory ensure you choose the right card for your camera

It's All in the Edit

How many times have you taken a photograph and when you've finally got the prints back, you've seen something you hadn't noticed at the time of clicking the shutter? If a re-shoot is out of the question, you would just have had to live with the unsatisfactory shot. But that's all over now. With digital technology it's possible to salvage the situation, and perfect the picture.

Above: An old-fashioned mainframe computer

Workstation

Welcome to the modern photographic darkroom! You won't find any hazardous chemicals or clothes pegs and, you won't have to work in the dark. There are, however, a few things that you will need in order to take part in this exciting new digital world.

Computer

It's strange to think that, 30 years ago, home computers were rare and expensive machines. Powerful computers meant huge dimensions only suitable for use by institutions such as NASA; today the machines used in homes and offices are capable of ever more powerful computing.

As with digital cameras, rapidly developing technology means that the price of domestic computers is continually falling. You don't have to spend a huge amount of money in order to walk away with a powerful computer system that is capable of coping with your photographic needs. When purchasing a new system, shop around and try to negotiate some free accessories from the retailer.

Monitor

Your computer will come equipped with a standard monitor, but for digital editing you should choose a high-resolution screen that is at least 17 inches in size. You will appreciate a large screen when you are trying to examine intricate detail on your photographs.

Read computer magazines for up-to-date reviews and offers on the latest editing software packages.

Software

It is likely that your computer will be bundled with an array of software that will enable you to start using it straightaway. Your camera will also come with software that will allow you to take your first tentative steps into digital editing.

Most editing software will be supplied on CDs

Experiment with the software supplied with your computer or camera and any programs that you can download for free from the internet, before you spend money on expensive editing software. You may find that these packages will serve your needs more than adequately. It can be tempting to purchase fancy software that contains more gimmicks, but you'll find yourself still using the same few editing tools over and over again.

Scanners are as much a part of the digital imaging world as developing chemicals are in the world of traditional photography.

Scanners

Scanners have become increasingly popular with domestic computer users as the price of these peripherals has dropped. Although it is often tempting to buy a scanner separately, it is best to buy it together with your main computer package.

This will ensure that the items are all compatible. One aspect of scanners that is not often addressed is the fact that they can be used to create pictures in a similar way to a digital camera (see Chapter Seven). A less common but equally useful addition is the film scanner. These are specially designed to work with conventional film. They can scan conventional negative and transparency films so that you can work with them in the same way as you would with a digital image, and come with purpose built film holders.

Top: A scanner that can handle film negatives, and transparancies

Right: Many scanners have the ability to scan slides as well as prints

Editing images

Perhaps the biggest lure of digital imaging is that you can easily fix so many problems that in the past were insoluble either technologically or due to budgetary constraints. Editing software packages will enable you to correct annoying little mistakes.

This software provides you with a set of tools and tricks, containing the electronic equivalent of pencils, erasers, craft knives, and paints, with which to alter your pictures. Not only will you be able to change elements around the main subject, you will also be able to alter or even completely remove the subject from the scene. Editing software is also capable of changing the very texture of an image, allowing it to gain greater depth and resonance.

But, before tackling any editing uppermost in your mind should be sorting the good pictures from the bad ones. You should delete any images that are out of focus, obscured, unintentionally blurred, or just plain boring! There are some things that even digital editing can't fix.

Don't waste your time editing poor images, just delete them

Software lets you arrange and alter images

Buying software

A range of editing software packages are currently available, but perhaps the best known is the Adobe Photoshop system and Adobe Photoshop Elements, aimed at beginners. Before purchasing check out the variety of packages that are available.

Other software packages, including Jasc PaintShop Pro, Roxio EasyMedia Creator, and MGI Photo Suite, offer similar functions. The software package that you decide to purchase will depend on your particular needs and level of skill and, by no means least, the price.

Before you purchase editing software, some of which can be expensive, you should search the internet to see if you can download some free samples. Photography magazines are also a good source for obtaining trial samples of software. Some of these giveaways provide a step-by-step onscreen tutorial for new users to follow. Once you have your software always look out for updates so you are working with the latest version.

Before you begin to change your images, the first thing you should do is ensure that you have an original copy saved. Keep an unaltered version of the image that you intend to edit on a CD or on your hard drive, as a safety precaution in case things don't go according to plan. It's also advisable to keep updated versions of your photograph as you progress through the various stages of editing. Label each version appropriately, so that you don't need to start over from scratch and you'll know where each one fits into the editing process.

Finally, always save your work as you go, and don't worry if you are not happy with the results as you will be able to undo work—so don't be afraid to experiment with new techniques.

Background

One of the elements that photographers want to change most frequently is the background in their photographs. It can be all too easy to overlook the background when you are engrossed in the main subject in your viewfinder.

You don't need to settle for distracting elements or imperfections in your pictures any more. Simple corrections make a huge difference.

There can be all sorts of distracting elements that can spoil your picture—signs, cars, trees, or even other people—and draw the eye away from the main focus of interest. All of these items can be removed with editing software.

Generally, if you remove an item you will be left with a space that has to be filled. By using software you'll be able to copy or "clone" another area of your image and use it to fill the gap. This is done by using one of the software tools, such as an onscreen brush that paints over the area. The brush size can be altered so you can cover large or more intricate areas with each stroke. Sorting out the background takes some practice but you will find that it will be one of the most useful tricks in your software package.

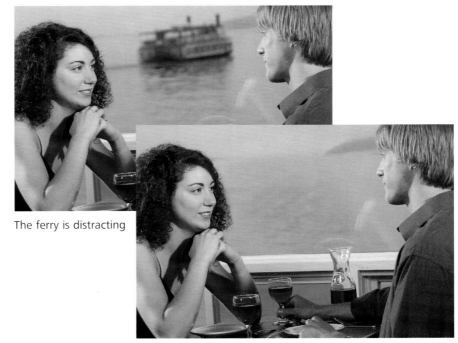

The ferry is distracting

The ferry is removed and the woman becomes the main focus

Above: Editing by hand was very time-consuming

Patching

This is used to cover up unsightly marks or spots on an image, from a speck of dust on the lens to a pimple on a model's nose. When covering a blemish on a subject, an area of clear skin can be cloned and then patched over the affected area.

This is also a handy tool to have if you want to blank out lettering. For example, if you are selling an automobile in a magazine or via the internet and don't want your license plate displayed for security reasons. With patching, you can keep the plate in the shot but erase the numbers and letters.

An unsightly mark on the girl's cheek

The mark has been partially removed

The mark has now been fully removed

Brightness

There are times when you will have taken a picture and adjusted the camera settings appropriately, but still do not have the results that you want. Perhaps the sky is overcast in your beach shot or you have a bright sunlit scene when you wanted a dark, menacing look.

If the weather or the settings on your camera let you down, all is not lost - you can alter the brightness of an image to make it more acceptable.

Editing software will allow you to adjust the image across the tonal range and automatically select the correct brightness and contrast to produce an evenly balanced scene.

This is also a useful tool for correcting skin tones, especially when the problem has been caused by artificial light, such as the flash giving somebody a washed-out look. In order to gain the correct contrast throughout the scene, you should access the software's histogram, which indicates areas that are overexposed or underexposed. It works in the same way as the histogram on the camera (see Chapter Three), though in more detail and with more options. By looking at this graph you can see how the tones have been distributed across the image. When the contrast is incorrect, the results may be flat and uninteresting because you are losing some of the detail.

This well-composed image is too dark

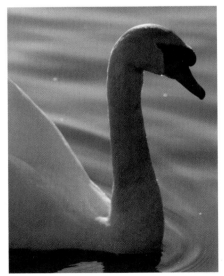

Light improves the swan's profile

Colour

With conventional photography, when you wanted to emphasise bright colours you had a few options. You could use a polarising filter, add a burst of light, or shoot using a slow ISO film with a high resolution. It's the same with digital photography, but with one big difference: you can change the final results with digital images.

Your camera will have a mode that will automatically adjust your colour settings. It's done using the white balance setting (see Chapter Three), which enables the camera to adjust itself according to the colours in front of it. If this still does not produce the results you are after, you can rectify the problem using a colour-correction or colour-management function in the editing software. Depending on the software you are using, you may be able to play with each of the primary colours individually.

It is important, when adjusting colour balance, not to overdo it. There is a thin line between rich, realistic colours and outlandish, garish ones. If you select an item of whose exact colour you are sure, maybe a plain white or black, you'll be better able to judge what the true colours of the rest of the image should be.

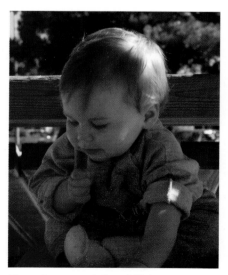

The colours are dull and lifeless

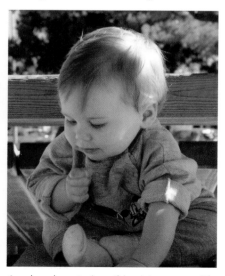

A colour boost gives this picture more life

Cropping

On occasion, you'll need to crop an image. This means removing an object by cutting straight down one side of the picture or deleting an empty space that does not contribute anything to the overall composition.

One of the easiest ways to edit a picture is to crop it. This lets you exclude unwanted elements or highlight certain aspects.

You can also crop a photograph in an effort to increase its impact. By homing in on one particular aspect, for example, an eye in a portrait or someone's hands, you can change an average picture into a more abstract and challenging study.

Another reason to crop can be if you want your picture to fit a particular format. You can change a portrait shot into landscape format or cut a photo to fit a particular size, such as a postcard or a box on a web page.

Cropping a photograph also means that the size of the data stored on the image will be reduced, making it easier and quicker to download and transfer via the internet. As with all editing, make sure you retain an original copy in case you are not happy with the end result.

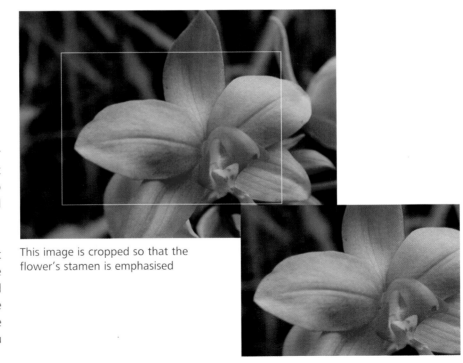

This image is cropped so that the flower's stamen is emphasised

Although it's possible to make images appear sharper, it is always best to get your image as pin sharp as possible when initially taking the photo.

Sharpening

There are times when almost everything in your photograph is just right - the background is dramatic, the foreground is uncluttered, the lighting is just right, and the colour is correctly balanced - but the focus is not as sharp as it should be.

A slightly exaggerated example, although sharpening will certainly improve the clarity of your image

With digital photography this can be remedied, as editing software has the ability to sharpen an out of focus image. Even so you can't work miracles, so if an image is poorly focused or blurred, not even the best software package will salvage it.

The software works by heightening the contrast between the edges of the subject within the image, though the procedure for sharpening varies depending on the software system you are using. It is a good idea to enlarge the image you are working on to see in detail the process that is taking place. Sometimes it's possible to sharpen an image by selecting each small section manually, rather than letting the software estimate where the image needs to be sharpened.

Soft-focus

Traditionally, soft-focus images were associated with romanticised portraits. They were achieved by attaching a soft-focus lens or filter to the camera. The same result was also accomplished by stretching a pair of very fine pantyhose across the lens.

You can produce the same effect with digital imaging. Soft-focus can produce some flattering results as any sharp lines or wrinkles are reduced, though it should be avoided if you are looking for a more candid or realistic shot.

When using soft-focus, you should be aware that, because the foreground and background of the photograph are very slightly out of focus, the viewer's eye will be drawn more closely to the main subject area.

Some scenes seem to lend themselves naturally to soft-focus, but you don't always have to go for the cliched set up.

Left: You can establish a romantic or artistic tone

Editing tip

Layers
When you initially take an image, it consists of one layer. When you are editing, it is best to create different layers of the same print, as this allows you to work separately on each different aspect of the photograph, such as the background, foreground, and the main subject.

A note about "noise"

* Traditionally in photography, grainy photographs were the result of using very high-speed film to shoot a subject in low light. The combination could result in poor definition and an uneven texture. Depending on the style of picture and the subject, some images can benefit from this effect, such as monochrome pictures of nudes. Indeed this effect was often added to non-grainy prints to add extra depth and texture.

* This same grainy effect is referred to as "noise" in digital imaging. Here, again, it is the result of a high ISO speed and inadequate lighting. If grain is something that you want to include or explore as an artistic element, you can do so by using editing software and taking the unpredictability out of the equation.

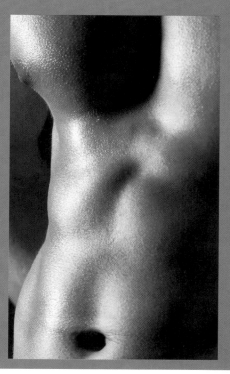

There are times when grain is introduced to add texture

Manipulating images

One of the reasons for switching to digital photography is the freedom that it offers. Many of the tools available with editing software for covering up mistakes made at the picture-taking stage can also be used to radically alter the image.

While the aim of most digital editing is to improve images without the viewer noticing, sometimes the out-landish approach can work well.

A photographer can use the editing software to create something unique, through the subtle use of special effects. Unless you are aiming for a specifically artificial look to your photographs, it is generally the case that less is more with image manipulation. Although the term may sound extreme, it is possible to make some very subtle changes to your pictures that will improve them greatly.

Examples of obvious but striking image manipulation

Change of tone

There can be times when a change of tone can enhance an image. Like many editing techniques, it's not a device that can make a poor image into a good one, but it can certainly improve an already strong photograph.

The colours vie for the viewer's attention

The mood of the image has changed

The photographs that tend to respond best to toning are those consisting of simple components. Landscapes and portraiture, in particular, lend themselves to this type of alteration. It helps if there are not too many distracting elements within the composition and some good strong lines, although toning an image and removing the colour will also help to lessen the impact of some distracting features.

Toning is a very simple procedure in the digital age and does not have to be limited to a single colour tone. It is also possible to tint an image subtly so that there is just an underlying hint of colour that runs through the picture. In the same way that you can boost the colour saturation in an image, it is also possible to desaturate an image. If you were to

remove all of the colour from your photograph you would be left with a blank canvas, so desaturating an image can allow you to look at the picture with new eyes. Sepia is a very popular colour tone, giving your pictures a warm brown hue, although it does not suit every subject and is best used sparingly. There was a time in the mid-nineties when toning was very much over-used on monochrome images.

Editing software can make an ordinary colour photograph look like an infrared image, this effect can give people a ghost-like appearance and look very atmospheric. This is done by removing the colour from the image, altering the balance of the red, green, and blue values drastically and then reproducing the image with the new settings.

The vertical and the horizontal

Buildings can make great subjects, but certain problems tend to recur especially when taking a shot from ground level. The lens and building can create an optical illusion.

Editing software can create fantastic images but it can also make the extraordinary look ordinary.

You may find vertical lines become distorted so that the building in your shot appears to be toppling over. This illusion can be corrected by the use of a distortion tool, which will pull out the converging vertical lines.

In the frame

How a scene is framed by the camera can change our perception of an image. Taking a picture at a slightly skewed angle may create a more interesting shot in certain situations.

Where a picture will eventually be displayed can also impact on how you compose an image. This is especially true for the internet, where an image can be surrounded by text or less conventional frames. It's worth bearing in mind that, while clever framing can enhance a good photograph, it will not disguise a poor one.

Right: An unconventional approach works

This building seems to be toppling over

This image of a cruise ship is enhanced by the strong background of a sunset

Montage

This is a technique used frequently by artists; it is also referred to as collage. It involves building up a picture using parts of other images. School students who take various images from magazines and glue them to a large piece of paper are using this technique.

The modern digital equivalent is far simpler and is a much-used tool in contemporary design. The basic principle is that you clone aspects of one or more photographs and then insert them into another one. From this, it is possible to build up a new image from old ones. It is also possible to shoot images in a way that will make it easier to compile good montages,

such as shooting an object against a plain background so that it is easier to cut it out from the original photograph. It doesn't have to be a plain white background, though this will help your editing process, too. You should also try to get the whole of the subject in the frame, so that you can choose at the editing stage which parts you want to use.

Two separate images are combined to create an an unrealistic but nevertheless impressive image

Filters and photography
have had a long association
and this relationship
continues through
digital imaging.

Filters

Digital imaging has reduced the need for using filters, but they are by no means obsolete. We have been concentrating on corrections that can be made after the picture has been taken, but always attempt to get things right in the first place.

Filters can enhance conventional photography in the same way as they can improve digital imaging. It's easier to put a filter on a lens, to add warmth to a picture or create a soft-focused portrait, than it is to try to recreate these effects using a computer.

When you begin to edit your photographs there are numerous different filters and effects that you can use. It is possible to make your images look as though they have been produced with a paintbrush or to give them the heavy lines of a charcoal drawing. Utilising these filters will make your digital image resemble a handmade picture. This can work particularly well with still life compositions. Not all subjects will be suitable for some of the more bizarre and quirky filtering and manipulation devices.

One unusual effect is the stained glass filter. This divides your image up with lead-like lines and re-colours it so that it resembles stained glass. It is worth playing around with the colours to see what effects can be created.

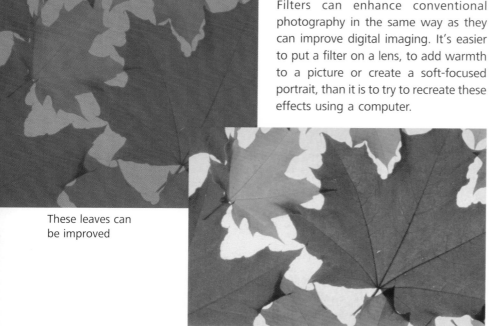

These leaves can
be improved

The filter improves their colour

Blending

This is a useful tool available with image editing software in which pictures are combined to create a single image. Like many other digital tools, it allows a traditionally time-consuming task to be completed a lot quicker than with traditional photographic methods.

Separate images are brought together to produce a stronger single image. When selecting your images, it is important to think about the structure of the picture and how the images will fit together as one.

These three separate pictures were blended together to create one single strong image

There are many ways to remove red eye at every stage of the picture process and editing is no excep-

Removing red eye

In Chapter Three we examined how red eye can be overcome at the time of shooting. This common problem is a result of the flash reflecting against the blood vessels at the back of the eye, because the pupils do not have a chance to dilate when the flash is fired.

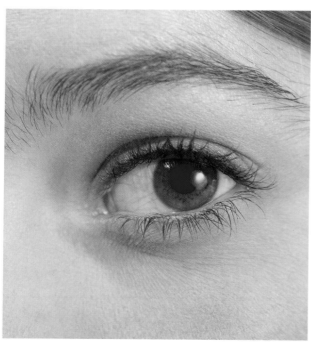

This red eye can be quickly and easily removed (see right)

Most compact cameras come complete with a red eye reduction mode in which the camera emits several shot bursts of light before the main flash triggers to allow the eyes to adjust. If your camera does not possess the red eye reduction feature or if it is ineffectual, it is still possible to eliminate the problem. Most basic editing programs will be able to address the issue with a special red eye editing feature. Otherwise you may have to use the cloning feature to take pixels from another area of the image to cover the offending spots. Make sure you enlarge the image before you edit it, to make the small details easier to work with. It is also possible to desaturate the red from the pupil so that you'll be left with a blank canvas. You can recolour the eye. You should, however, make sure that you replace any catchlights that will have been removed.

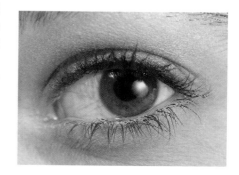

Resizing

Size can be an important issue, on occassions you may want to reduce or enlarge an image. For example, you may wish to print it and use it to create a postcard or Christmas card, to fit in a photo album or a particular picture frame.

There are several ways to resize your images, but they do not all have the same effect on your original picture. Editing software can resize an image without adjusting the volume of data held within the image. This is useful at times, such as, when you need to reduce the image size so that you can print a copy, but without compromising the quality of the picture for later use. You can also reduce your image size by removing some of the pixels, using editing software. This will reduce the quality of the image, but will make it far more manageable if you intend to use it on the internet.

Altering an image size may give you more flexibility, especially if you are planning to post it on the internet.

Left and Above: You can reduce the same image and maintain quality

Workstation worries

The computer is a common sight in workplaces around the world. As a consequence, many of us spend up to eight hours a day sitting at a desk staring at a screen, and we don't even think about any possible detriment to our health.

Top: Poor posture at your computer can lead to aches and pains

Bottom: The correct way to sit

Away from work, we very often continue to spend our own time on our personal computers, engrossed in checking emails, or surfing the internet. Computer culture has increased convenience and speeds up communication, but our love of technology can also take its toll on our health. If you are planning to spend time editing your images, it is quite likely that this will add to the time that you already spend on a computer. Here are some simple guidelines that will help you avoid some of the many potential pitfalls.

Install your computer and peripherals in a room that is well lit and well ventilated. These machines generate a great deal of heat, so they must be located in an area that has good air circulation. Don't place your monitor in direct sunlight or in the path of any light that might affect your view of the screen or cause reflections. If the room tends to get too hot, you may need air-conditioning; computers are liable to overheat in hot weather.

Working in a cluttered or a messy environment can cause tension and frustration.

Make sure that you have enough power sockets in the designated area for the amount of equipment you wish to operate. Don't be tempted to overload electrical sockets for the sake of convenience, this could overload your system. If electrical work needs to be carried out and this is not your specialty, enlist the help of a professional.

Remove clutter from your workstation. Unnecessary clutter may mean that you're unable to locate the things that you need, whether that means an old photo you wish to scan or even the scanner itself. Don't allow beverages and electrical equipment to mix, they are not compatible! A messy, confused workspace can easily affect your work. Only spend an hour at a time at your desk. Staring at a monitor for long periods can result in headaches. Take a break and stretch your legs frequently. Don't be tempted to replace one screen with another, avoid watching television during your computer screen intermission.

It is important that you adopt a good posture while sitting at your computer. Your feet should be flat on the floor and your elbows should be level with your desktop. Ensure that your chair is supportive as well as comfortable and set at the correct height.

Some unobtrusive distraction can also be useful if you are involved in a long editing session, some background music can provide welcome relaxation.

Below: Staring at the computer for long periods of time can cause headaches

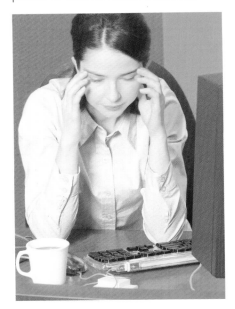

The Final Print

Traditional photographic hand-printing is a skill that can take many years to master. It is a time-consuming business that entails working in a darkroom using toxic chemicals, not necessarily the most conducive environment to creating great pictures. All of this has changed with the advent of digital imaging, and now good quality prints can be produced without much effort.

There will be times when you'll want to print off some of your images for posterity or for friends who don't have computer access.

Printing images

With conventional photography, we had few options when viewing our pictures. We could look at them via a slide projector or on paper. Now we can see the shot on the camera's LCD, a computer monitor, or even a television set.

For many of us, it is now just an afterthought to print our images onto paper. However, a printed photograph has a sense of permanency that is not present with digital images. Printed images can also acquire a certain added depth and detail that is not as easily conveyed through an electronic format. Also, it's worth realising that an appropriate mount and frame can transform a reasonable photograph into a great one.

Photographic film manufacturers, who once relied on printing and processing for a large part of their business, are now trying to keep up with our changing tastes. Photographic processing stores are able to process photographs from your camera's memory card. Firstly, they download the pictures onto their

computer and then you can to select the images that you want to have printed. Using this method also allows you to talk through your requirements with a professional.

If you are confident with how you would like your images to turn out, you may wish to use one of the automated machines that have recently begun appearing in locations such as railway stations, bus stations, and airports. These kiosks will print pictures from your memory card or a CD, as well as scanning existing photographs and printing copies from them. Some of them allow you to alter and edit various aspects of your image, such as adjusting the contrast, removing red eye and adding text. You can choose all of these options through a touch-screen menu system.

Simply click on the icon to begin printing

You don't even have to leave your home or office to get prints. Many companies now offer an online service that will let you email your images to them via the internet. You can select the images you require and these will be printed off and mailed back to you. This can be a particularly useful service if you are away from home, as you could order your prints online and they'll be waiting for you when you get home, with the added advantage that you can free some space on your memory card for more vacation pictures.

If you have a printer with your computer, you can save money and time by printing images yourself. Specialist equipment is not required to produce prints and, by printing them yourself, you have more control over the final image.

Above: This multi-functional all-in-one incorporates a scanner and printer

Above: Domestic inkjet printer

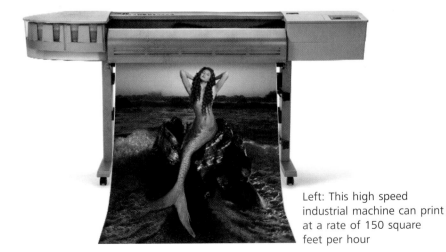

Left: This high speed industrial machine can print at a rate of 150 square feet per hour

Monitor and printer calibration

✴ **Inkjet printers most commonly use four colours: cyan, magenta, yellow, and black (CMYK).**

✴ **Monitors only use three colours for their displays: red, green, and blue (RGB).**

✴ **If the photograph that comes out of your printer bears little colour resemblance to the image on the screen, you'll have to calibrate the two systems and adjust the monitor to match the printer's output.**

✴ **A number of software programs are available that will give you a step-by-step guide to calibrating your system.**

Home printing

A wide range of printers is currently available, from compact portable printers that will produce standard 6x4 inch prints, to much larger varieties that can be used to print 6x6 foot posters or even to produce t-shirt transfers.

The inkjet printer is by far the most popular type used for producing domestic prints and we'll concentrate on this one for the moment, though there are also bubble jet, dot matrix, and laser printers on the market. Inkjet printers are the type most likely to be supplied as part of your computer package and are simple to install and use. On the downside, the ink cartridges can be very expensive in comparison with other types of printer, and they are slow but very effective for printing quality images.

The software supplied with the printer will alert the user when the ink is running low. The printer will link up to your computer, using a serial or parallel port or a USB connector. The printer will come with a driver in CD format, which you will have to install before your computer will recognise the new hardware.

With most printers, ink is stored in two separate cartridges; one for colour and the other for black ink. When the ink runs out it is possible to refill the cartridges. Inkjet printers use four or six basic colours, which combine to produce over 16 million different colour combinations to create the photograph. The final photograph is a result of the ionised ink being sprayed on to the paper. The image consists of millions of tiny dots and the resolution of the printer is measured in dots per square inch (dpi). The more dpi, the better the quality of the image, so a 1200dpi printer will not to produce the same quality prints as a 2400dpi printer.

The camera links up to your computer via the USB cable

Linking your camera up to a printer via a computer is an easy and quick method of obtaining high quality hard copies of your favourite images.

You'll get a good idea of the images worth printing off by viewing them on a computer screen

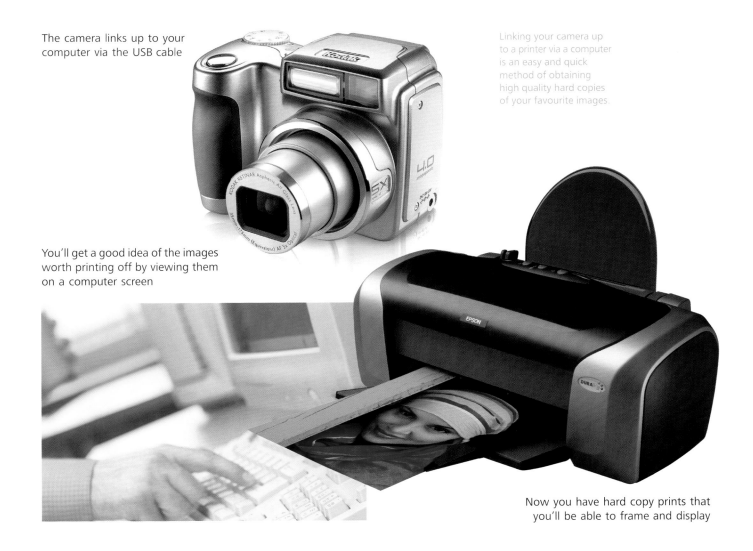

Now you have hard copy prints that you'll be able to frame and display

When purchasing a printer, always check the price of new toner/ colour cartridges, as they can work out to be expensive if you are producing a lot of prints

Other printer types

Although you might use an inkjet printer to produce your photos at home, other types of printer are available. If budget is not a consideration, take a look at other options available, such as laser printers.

Laser printers are most commonly found in offices and other commercial settings. They are less portable then inkjet printers, because their components are larger and heavier. Laser printers rely upon a dry powdered ink called a toner instead of the wet liquid found in inkjet cartridges. The pictures are achieved by a combination of electrically-generated heat and pressure from an imaging drum. Laser printers are available in both monochrome and colour formats, but while black and white printers are becoming more

affordable, colour systems remain less so. Colour laser printers produce fast high-quality prints, but also have their limitations with regards to the paper sizes and types they accept.

Dot matrix printers work in a similar way to typewriters, with tiny pins striking an inked ribbon. They are not suitable for digital image printing and they are also very noisy.

Digital photo centres or kiosks (see picture), are regularly appearing

Before you print

✳ Set your printer to its highest quality setting for colour photos.

✳ If your printer allows you to choose between quality and speed, select quality. It will print more slowly, but the resolution will be better.

✳ Make sure the ink nozzles are clean. By accessing your computer's control panel you can command the printer to clean its own nozzles automatically.

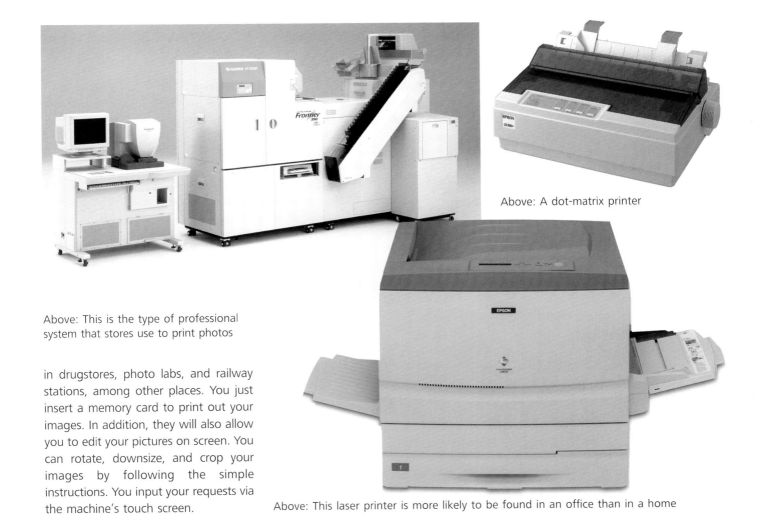

Above: A dot-matrix printer

Above: This is the type of professional system that stores use to print photos

in drugstores, photo labs, and railway stations, among other places. You just insert a memory card to print out your images. In addition, they will also allow you to edit your pictures on screen. You can rotate, downsize, and crop your images by following the simple instructions. You input your requests via the machine's touch screen.

Above: This laser printer is more likely to be found in an office than in a home

There are no restrictions on producing good prints even if you don't have a computer. Companies now offer systems that enable you to print without a PC.

Printing without a PC

It is a common misconception that you need to have a computer in order to get any use from a digital camera. An even more popular myth is that you need a computer in order to print your own pictures.

Printers are now available that can be attached directly to your camera or memory card, without the need to connect through a computer. The advantage to using these printers is that you do not have to spend money on a computer or on processing your prints at a specialist store. They are fairly compact and because they are dedicated to image printing you can calibrate them solely for this purpose.

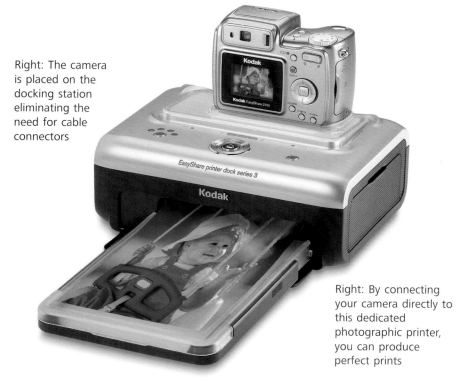

Right: The camera is placed on the docking station eliminating the need for cable connectors

Right: By connecting your camera directly to this dedicated photographic printer, you can produce perfect prints

Paper choice

A lot of paper types are suitable for making photographic prints, some performing better than others, depending on the task. Although at first glance many papers look the same, they may have different finishes, densities, and compositions.

This is another area of digital photography in which experimentation is beneficial. The various manufacturers produce a wide range of papers and some even offer assorted sample packs, which are useful if you want to see what effect the paper will have on your image. Here we take a look at the most commonly used types of paper and examine when you should use them.

Multifunction plain paper

This is the variety of paper that most of us will encounter everyday. While this paper is cheap, plentiful, and ideal to use for text, it does not easily absorb the vast quantities of ink required for photographic images. When you print images onto this type of basic paper, the results will be low quality and often blurry. It is useful, however, when testing for picture size and experimenting with cropping the image.

Inkjet paper

Like multifunction plain paper, basic inkjet paper is also readily available and economical to use, especially when bought in bulk. Although this paper absorbs ink better and thus produces slightly sharper results than plain paper, it will not produce top quality images.

Glossy photo paper

This is possibly the best option to go for if you are using an inkjet printer and want a consistent standard

Major film manufacturers provide a wide variety of good quality photographic papers

Left: The acid content in photographic paper contributes to its decay

of prints. It is specifically targeted at the inkjet market and can produce some stunning results with enhanced colour saturation. Matt paper is also available for an alternative finish.

Art photo paper

If you want to produce something unique or special, try printing on art paper, as it absorbs the ink differently from glossy paper. It is not suitable for all subjects and can sometimes give flat results that lack contrast, but the paper's texture tends to work especially well with black and white photography.

Anti-acid

We have all seen old documents or books whose pages have turned yellow and dull. This is caused by the acidity in the paper, the acid slowly eating

There are specialist papers available for various subjects including transferring images on to t-shirts.

away at it. This can be a problem if you are printing images that you want to preserve carefully. You should check that your glossy photo paper is acid-free if you are worried about important photographs. Acidic paper can also be treated with a special solution to remove the acidity without damaging the image; the conservation department at your local museum can give you advice.

Matching print to paper

Many major printer manufacturers also make consumables. These are often more expensive than the lesser-known brands, but try to match your printer, paper, and ink, as they will have been designed to work together. However, it may be worth experimenting with cheaper brands if you are trying to save money.

Below: This violin has been printed on art paper to give it a textured look

Scanning images and objects

Scanners have a multiplicity of different purposes that allow you to turn conventional photographs into digital images. They work in a similar way to digital cameras, relying on CCD light sensors, while they look and act like photocopiers.

Above: The flower was placed directly on the scanner to achieve this image

Right: Scanning objects directly produces a good clean image, ideal when selling items on the internet

They are linked to the computer via a USB connection or a FireWire cable and come with software to help with installation. The scanner is likely to be powered through the computer and, unlike printers, it does not need a separate power source. On a PC with a Windows operating system, your scanner can be accessed via the Scanners and Cameras icon.

By scanning your existing hard copy images you will be able to edit and manipulate them using software as you would any digital image. You can also use the scanner to make copies of photographs if you have lost the original negatives. When you select the scanning option on your system you will be given a few choices. Your decisions will be dictated by what you intend to scan, for example, a colour picture, a greyscale picture, or black and white text. Even though your scanner may be on standby, it will take a few moments to warm up. Before deciding on whether you want to go

Above: A USB cable

A flatbed scanner can be used to capture images directly just like a camera

ahead and print the scanned document or picture, you can see a preview image on the computer screen and make any necessary adjustments.

It is also possible to scan objects, in addition to pictures and text. If you can fit the object, such as a flower, on to the glass and it is not so heavy that it will break it, you'll be able to scan it with varying degrees of success. Try to ensure that the objects you're scanning can fully make contact with the glass. For best results, ensure that the glass always remains clean and scratch-free.

Scanning a traditional photo will allow you to manipulate it like a digital image

Moving Images

8

Throughout this book we have been looking at the unique qualities of digital stills cameras and sometimes comparing them to conventional cameras. In this chapter, though, there can be no comparison. Some of the cheapest, bottom-of-the-range digital compact cameras have the facility to shoot short video clips, something that even top-of-the-range film stills cameras are not capable of.

Lights, camera, action!

There can be occasions when it would be useful to have a video-camera to hand in order to record certain events, such as the winning touchdown at the Superbowl, your child taking his or her first steps, or even a historic world event you were able to witness.

Above: Traditional 35mm movie film is cumbersome to transport and store

Digital cameras make it easy for you to shoot your own mini-movies. In order to select the movie mode on some cameras you may need to use the menu, while on other cameras you may just need to flick a switch to start recording. As with still images, your camera may let you select the size and quality of the moving pictures. The same shutter button that you press to take still photographs is used to start recording the moving images. REC will appear on the LCD when you begin shooting. As well as recording the moving images, the camera will record the sound using a built-in microphone. When you've finished recording, press the shutter button again to stop recording.

You should be aware that shooting movies on your compact digital camera will take up a lot of memory space and you will only be able to get a few minutes worth of footage when shooting on a high-quality setting. Shooting movies will also seriously drain the power source. It's partly because of these limitations that movie mode on a digital stills camera is viewed by some as just a gimmick. Nonetheless, it is still a useful tool to have. Before recording your movie footage, you should consider carefully what you will be shooting, as you will quickly run out of memory space.

You will not be able to activate all of the modes that are available for shooting in the stills mode. Think about the conditions in which you will be recording, as you will not be able to

Left: This classic night-time cityscape scene provides a good establishing shot for a short movie

Below: When following moving objects it is best you remain static in one location and follow the action through the viewfinder or LCD. Always try to fill the frame

use the flash, so if the lighting is poor, you may be disappointed by the results. It's quite likely you won't be able to alter the zoom either, though you can compensate by moving closer to the subject, or setting your zoom lens before you begin recording.

The LCD will allow you to see what you're shooting in the same way it does with still pictures. Steady hands or a tripod will help you create smooth panning shots. When holding the camera, make sure that your hands or

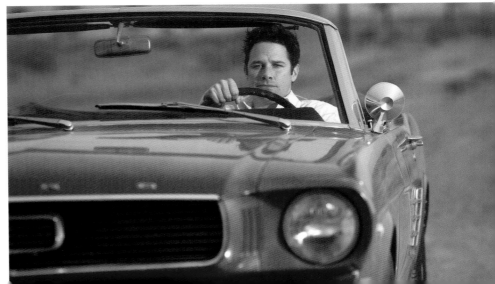

You can have fun with your camera's movie mode. Take short clips then edit them together to produce a seamless feature.

other objects don't obscure the camera's built-in microphone. It is also worth noting that the microphone will pick up sounds indiscriminately because you cannot direct or zoom the microphone closer to the subject. Therefore, if you are recording a scene in the distance, the microphone will be limited to recording sounds closer to the camera, which can result in a clip in which the audio doesn't match the on-screen action.

As with stills photography, people can be shy about being videoed. However, unlike stills photography, stationary posing does not work well. It's best to engage the subject in conversation or to use it as a chance to get candid footage of someone occupied at work or play.

This clip is so dark because the flash cannot be used in movie mode

Action sequences work best of all but it is important to choose your vantage point carefully

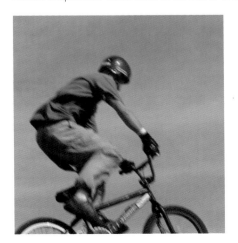
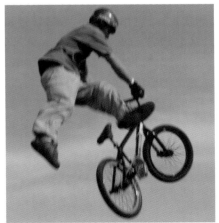
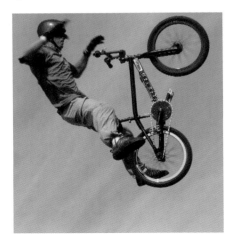

Using audio

The built-in microphones incorporated in many digital cameras do not have to be limited only to recording sound on movie footage; they can be used to make verbal memos when you are shooting still images, too.

Above Left: Your camera's microphone is not as powerful as your camera's zoom lens so you will not be able to eavesdrop on distant subjects

Above Right: In movies, the sound is usually recorded using a boom microphone—a common sight on movie sets

When you are recording movie footage don't have too many voices or sounds in the background at once as this will sound confusing. Sound engineers get over this problem by recording the various artistes' lines and sound effects onto separate tracks. Along with the image, you can record a short message—anything from a few seconds to a few minutes, depending on your camera. Use this feature to add detail, such as the time and date, which will be useful when editing or archiving your images.

If you are recording your voice, don't speak too close to the microphone because this could result in a muffled reproduction. Speak slowly and clearly, holding the microphone at least six inches away from your mouth.

Viewing video

When you have all of the footage you need, you can play it back via the camera's LCD, switching from record mode to playback mode. You should be able to start the film clip via the navigation buttons or by accessing the menu.

You can view your movies on your camera's LCD or via a monitor. Monitors are best because the larger size enables you to see more detail.

The soundtrack will be audible through a camera's speaker, and the volume will be adjustable. The navigation buttons will allow you to advance or rewind the video. It is also possible to play back your video through your TV set, by using the AV cable that should be supplied with your camera and linking it up to the video-out socket on your television.

Below: Select the movie camera symbol and press the shutter to begin filming

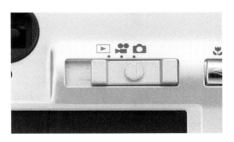

It can be very slow uploading or downloading movie footage. Be selective about what you shoot and delete as you go.

FireWire

If you are thinking of transferring or downloading video clips on a frequent basis, it is worth considering a FireWire connection. This high-speed cable link, also referred to as IEEE 1394 or iLink depending on the manufacturer, enables you to transfer large files.

FireWire is compatible with many electronic devices, such as scanners.

It is cheap and simple to use and does not need a host, meaning it does not require a computer in order to operate. Apple Computers had an interest in the development of this technology and as such it is a product that is now built in to System X and its variations. With digital technology becoming more popular, FireWire is becoming an essential accessory even for the PC.

If you are planning to transfer your movie footage via the internet, you should remember that these movie files contain a great deal of information and, unless the recipient is using broadband, it will take a while for the file to download.

Editing

Shooting video clips is only the first part of making a short movie, the real creative fun starts when you begin to edit the footage. As with still digital images, you will have the option of deleting the movie completely.

The current range of digital movie-editing software can really help you to create a polished package.

You will also be able to view your scenes on the LCD and then decide if you want them to remain. If you prefer to work from a bigger screen, you should download your footage onto your computer's hard drive. You will then be able to use specialist video-editing software that is unavailable on your camera. This software will allow you to add voice-overs, graphics, and a soundtrack to your movie and can be purchased on the internet where you can sample the product before buying it. By using these additional tools, it is possible to produce a reasonably polished and professional-looking package. However, try not to get carried away with editing or the use of special effects, unless they enhance the footage in some way.

Select a software package that will cope with your needs. Visit manufacturers' websites online as many will show you a sample of what can be achieved

Above: Cotton buds are a very useful addition to your cleaning kit

Below: Specialist lens cleaning solution

Maintaining the gear

After spending your hard-earned cash on a digital camera and a few accessories, you should spend some time looking after your purchases. While SLRs tend to be robust and hardy, the average compact digital camera is a slight, fragile piece of equipment.

Digital cameras are particularly susceptible to damage from dust and dirt, though there are steps that you can take and devices that you can use to protect and maintain your equipment. The bulb-shaped blower is a particularly useful cleaning device. It will blow dust and other foreign bodies from the lens. Touching the glass in the lens with your fingers must be avoided, because this can impair your images and damage the lens. You should also use a specialist cloth to keep the lens free from dirt and grime, along with some antistatic lens-cleaning fluid. Another big enemy of your digital camera is humidity and moisture; cameras are most vulnerable to this, especially when moved from a cold environment to a warm one, such as when you bring a camera into a heated room after being

in very cold conditions. If the camera is exposed to these extremes in temperature, seal your camera in a plastic bag for an hour or so, to allow the camera to acclimatise and prevent moisture from forming inside it.

Try to keep your camera dry by protecting it during wet weather. You can buy small packages of silica gel that absorb excess moisture; place a few inside your camera case or bag to protect your camera. Dirt can also accumulate in your camera bags, which can be difficult to remove, though duct tape is particularly good at reaching bits of dirt and fluff in the corners.

One of the best ways that you can protect your investment is to insure it. Contact an insurance company to ask

Check with your insurance
company about coverage

about coverage costs for any equipment that you've bought. It is also worth checking your household contents insurance as your camera may already be covered or could be added as a specified item. You should also take the precaution of marking your equipment with an ultraviolet pen. The ink from these pens is only visible when held under ultraviolet light. The police can often reunite owners with their property if they have taken this precaution. Write your phone number, postcode, and house number on your equipment.

Glossary and Index

9

The following pages contain an easy-to-use reference to key phrases and terminology that you will come across when you enter the world of digital photography. The glossary is followed by a handy index.

A—Z glossary of terms

Aperture
Circular opening inside the lens. It controls the amount of light that passes through to the image sensor. It is measured in f-stops, these being f/4, f/5.6, f/8, f/11, f/16, f/22, f/32. The aperture affects the depth of field. As the aperture opens wider, the depth of field decreases.

Application
Computer program designed to perform a particular task.

Archive
This is where copies of images or files are stored.

Artifacts
Optional features that can be added to image capture, such as sound. Artifacts can also affect image quality.

Attachment
Document or image file that is sent in conjunction with an email.

Background
The first and bottom layer of a digital photograph.

Back-up
Making copies of an original image or file on a disk or a hard drive for safekeeping.

Battery
Digital cameras require batteries, either disposable or rechargeable. For heavy use, rechargeable batteries are recommended. The instructions with the camera indicate the types of battery it uses.

Black and white
All of the colour can be removed from an image to replicate monochrome film. A sepia effect can also be created.

Blog (Weblog)
A personal diary published on the Internet, which can also contain digital images.

Bluetooth
Technology that allows wireless communication between various electronic devices.

Bite
The smallest unit of digital data. There are eight bites to a single byte.

Buffer

Short-term memory storage device.

Calibrate

Adjusting a device, such as a printer or monitor, to a specific setting so that it will produce accurate results.

Camera Shake

This manifests itself in the form of blurred or fuzzy images. It occurs particularly in poor lighting conditions if the camera is not adequately supported, or the photographer does not have a steady hand.

Card-reader

An accessory that accepts the memory card from your camera and can then be linked to your computer to download images.

CCD

Initials for "charged-coupled device." This is a camera's image sensor.

CD-RW

Rewritable CD on which you can record data. RW means that the CD can be re-written with new data.

Cloning

Copying one part of an image and placing it in another part of the same scene. Useful for eliminating blemishes.

Colour depth

This refers to the amount of colour held within an image. It will have a direct effect on the quality of an image.

Colour saturation

The strength of the colours contained within an image.

CompactFlash

A popular form of memory card.

Compression

Electronic squeezing of an image. Compression can cause loss of quality, in an image so it is important to try and get maximum quality for minimum image size.

Cropping

Removing part of an image for aesthetic or technical reasons.

Crash

Computer breakdown while in use. The computer may not necessarily switch itself off but the screen and cursor may "freeze" and data may be lost.

Delete

Erasure of image or file, accidental or deliberate, from a memory device on a camera or computer.

Depth of field

The extent of the area in front of and behind the main subject that remains in focus. A shallow depth of field will blur the background and foreground, while a wide depth will allow a wider area to stay in focus.

Digital Zoom

Digital software that enlarges a specific area within the image to give the impression of zooming in on it.

Downloading

Method whereby images and data are transferred from one electronic device to another, or from the internet.

Dpi

Dots per square inch—the way in which the quality of a screen image or printed photograph is measured.

Drag and drop

A technique that makes it possible to move items around on the computer by dragging them into position using the mouse. Useful for picture editing.

Driver

Software required by a computer to enable it to operate peripherals such as printers and scanners. Always use the latest version of drivers.

Dynamic range

Measurement of the amount of

brightness that is captured by a photographic image.

Exposure
Amount of light that passes through the lens and onto the CCD, controlled via the shutter and aperture settings.

F-stop
This denotes the extent to which the diaphragm within the lens can be opened and closed, increasing or decreasing the amount of light let into the camera.

Fill-in
Technique for adding light to shaded areas. Achieved by using a flash, another light source, or a reflector.

Firewall
Computer security software to prevent unauthorised access to your computer via the internet. An essential device for broadband users.

FireWire
High-speed data transfer device.

Focus
Process whereby a lens is adjusted to sharpen the outline of a subject.

Gamma
The amount of contrast and brightness

contained within a digital image.

GIF
GIF—Graphic Interchange Format, a popular compressed image format mainly used for the web.

Gigabyte
Equates to 1,024 megabytes.

Greyscale
Measurement of Greyscales are used for testing and calibrating image quality.

Hard copy
An image or document that has been printed out.

Histogram
Graph that displays the range of tones present in a digital image.

Hot shoe
The connection on a camera where an external flashgun is fitted.

Ink-jet
Printing technique whereby the printer sprays droplets of ink on to paper or other substance to create an image.

Interpolation
The act of increasing the number of pixels in an image in order to enlarge or improve it.

Iris
Tiny blades housed inside the lens. Their movement alters the size of the aperture and they work in the same way as the iris of the human eye.

ISO speed
International Standards Organisation, used to indicate the speed of traditional film and its digital equivalent.

JPEG
Joint Photographic Expert Group—format for reducing the size of an image file. Useful for internet transfer.

Kilobyte (Kb)
Equates to 1,024 bytes of information.

LCD
Liquid crystal display, a flat screen used to display a variety of information, generally located on the back of a digital camera.

Lossy compression
Computer process that reduces the size of a digital image but results in loss of quality.

Landscape format
When an image or camera is presented horizontally rather than vertically, it is referred to as a landscape format.

Megabyte
Represents 1,024 kilobytes of data

Megapixel
Unit representing one million pixels.

Memory card
Removable electronic chip device that is housed in the main body of the camera. It stores the images once they have been captured by the CCD.

Menu
The menu system allows the user to select different settings such as shutter speeds and white balance.

Monochrome
Another term for black and white images.

Navigation
Moving through the camera's menu system to view and possibly change various settings.

Noise
Result of using a high speed ISO setting, that can make an image appear "grainy."

Optical zoom
The optical zoom can increase the size of a subject by shifting the lens.

Overexposure
Effect caused by too much light passing through the lens onto the CCD, resulting in a bleached out image.

Pan
Pivoting a camera smoothly on the horizontal plane to follow an object or create a panoramic effect.

Palette
Variety of colours or tools available in software programs.

Peripheral
Any device, such as a printer, that is linked to a computer.

Pixel
Picture element. The pixels are what creates the image.

RAM
Random Access Memory—the electronic storage device used by computers.

Reformatting
Preparing a memory card to accept new data.

Resizing
Altering the dimensions or resolution of an image.

Resolution
Measurement of picture quality. The higher the resolution the better.

Saturation
Relates to the purity of colour.

Sharpening
Software tool that gives the impression of greater clarity.

Shutter lag
Delay between pressing the button and the camera capturing the image.

TIFF
Tagged Image File Format—a commonly used file format.

Underexposure
Image appearing to be too dark because not enough light has passed through the lens.

Upload
Transfer data from one device to another or transfer from the Internet.

USB
Universal serial bus—a port used to connect cameras to computer terminals and printers.

Virus
File or program that infiltrates and infects a computer's operating system.

White balance
System that helps to correct colour when images are shot in artificial lighting conditions.

Index